MARC
CHAGALL
EARLY WORKS FROM RUSSIAN COLLECTIONS

The Jewish Museum, New York
29 April 2001 – 14 October 2001

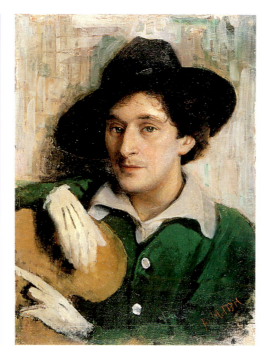

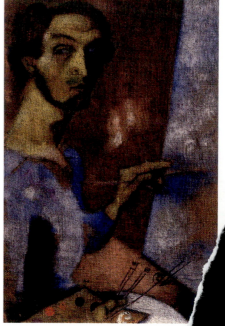

Plate 1. Yehuda Pen
Portrait of Marc Chagall, c. 1910

Plate 2. Marc Chagall
Self-Portrait at the Easel, 1914

MARC CHAGALL

EARLY WORKS FROM RUSSIAN COLLECTIONS

EDITED BY
Susan Tumarkin Goodman

WITH ESSAYS BY
Aleksandra Shatskikh
Evgenia Petrova

T·H·E
JEWISH
MUSEUM

The Jewish Museum, New York
Under the auspices of
The Jewish Theological Seminary

In association with

THIRD MILLENNIUM PUBLISHING
London

This book has been published in conjunction with the exhibition *Marc Chagall: Early Works from Russian Collections* held at The Jewish Museum, New York, 29 April 2001–14 October 2001.

Front cover: Detail from *Lovers in Blue*, 1914.
Collection Victoria S. Sandler, St. Petersburg
Back cover: *Woman and Rooster* (from *Mayselekh* by Der Nister), 1916.
The State Russian Museum, St. Petersburg
Table of Contents: Detail from *The Jewish Wedding*, c. 1910.
Collection Sinaida Gordeyeva, St. Petersburg

© 2001 The Jewish Museum, New York

First published in 2001 by Third Millennium Publishing,
a subsidiary of Third Millennium Information Limited
Shawlands Court, Newchapel Road,
Lingfield, Surrey RH7 6BL, UK

ISBN 0-9536969-6-0

Photo Credits
Unless an acknowledgment appears below, the illustrations in this volume have been provided by the owners of the works of art or by The Jewish Museum, New York. Every effort has been made to contact the copyright holders of all works reproduced in this book. However, if acknowledgments have been omitted, the publishers ask those concerned to contact The Jewish Museum.

All works by Marc Chagall
© Artists' Rights' Society (ARS), New York/ ADAGP, Paris

CONTENTS

DONORS AND LENDERS
TO THE EXHIBITION

DONORS

Marc Chagall: Early Works from Russian Collections is sponsored by

Major support has also been provided by a special appropriation obtained by New York State Senator Roy M. Goodman and administered by the Office of Parks, Recreation and Historic Preservation, an anonymous donor, Anne and Bernard Spitzer, the Robert Lehman Foundation, The Skirball Foundation, and OFFITBANK. Additional support has been provided by Credit Lyonnais, The Smart Family Foundation, The Edmond de Rothschild Foundation, Fanya Gottesfeld Heller, and other generous donors.

Endowment support has been provided by the Fine Arts Fund, established at The Jewish Museum by the National Endowment for the Arts and the generosity of Andrea and Charles Bronfman, Melva Bucksbaum, Barbara Horowitz, Betty and John Levin, Lynn and Glen Tobias, Bunny and Jim Weinberg, and the Estates of Ruth Roaman Epstein, Francis A. Jennings, Charles J. Simon, and Leonard Wagner.

This catalogue has been published with the aid of a publications fund established by the Dorot Foundation.

LENDERS

Museum of Art, Pskov
Krasnodar Art Museum
Regional Picture Gallery, Vladivostok
State Art Museum, Saratov
The State Art Museum of the
 Republic of Belarus, Minsk
The State Russian Museum,
 St. Petersburg
The State Tretyakov Gallery, Moscow
Vitebsk Regional Museum, Vitebsk

Collection Zinaida Gordeyeva,
 St. Petersburg
Collection Valentina Kosintseva,
 St. Petersburg
Collection Victoria S. Sandler,
 St. Petersburg
Collection N. Simina, St. Petersburg

Private Collections, Russia

FOREWORD

This is The Jewish Museum's second opportunity to mount a major exhibition of works by Marc Chagall, an artist whose paintings and drawings are quintessentially Jewish and yet endowed with an appeal that transcends religion, nationality, and culture. In 1996, The Jewish Museum exhibited a representative selection of the remarkable works of Marc Chagall. That beautiful and wonderfully received exhibition, which featured loans from collections in Europe and the United States, revealed the personal and stylistic development of the artist in his early years as a painter. In 2001, we are delighted to revisit the subject with another exhibition of important early works by this tremendously appealing yet complex artist.

The paintings, drawings and murals on exhibit and discussed in this catalogue are primarily works that have never been seen in the United States and murals from the State Jewish Chamber Theater in Moscow, which have rarely been on view in this country. The show has gained a special dimension through the inclusion of works by Yehuda Pen, Chagall's first teacher and a major influence on his development as an artist. The paintings by Pen,

borrowed from the State Art Museum of the Republic of Belarus in Minsk and the Vitebsk Regional Museum, have never been exhibited outside of Russia. In addition to illuminating Chagall's development as an artist, Pen's paintings lovingly depict a world, now lost, that still holds resonance for many Americans of Russian and Eastern European ancestry.

Marc Chagall was born in 1887 in Vitebsk, a town in the Pale of Settlement, the region where most of the Jews of tsarist Russia lived. Chagall worked and studied in Russia until 1910, and again from 1914 until 1922. While the paintings and drawings in this exhibition reflect the *shtetl* culture of Chagall's Vitebsk, there are references throughout to the larger world and the startling historical realities of a period that included the First World War and the Bolshevik Revolution. This exhibition is a window on the formative years of a legacy cherished by The Jewish Museum, with its vast collections representing the cultures of European and Russian worlds that no longer exist. It is also a window on the formative period in the life of an artist, trained in the years after emancipation for European

Jewry, who bridged the old and new worlds with a highly idiosyncratic vision and distinctive iconography.

For many years during the Soviet era, Chagall's works from this early period were labeled "decadent," made inaccessible, and were left virtually unknown. Often the curators who cared for the works did so in secret. Thus it is a great privilege to now have these collections made available to an American audience, who can enjoy the output of a great painter and gain a better understanding of how and where his extraordinary talent developed. How fitting that The Jewish Museum should offer this exhibition by Marc Chagall, who touches viewers of all backgrounds while remaining the artist most known to represent the nexus of art and Jewish culture.

My thanks to the donors, whose generosity has made possible this exhibition and catalogue (they are listed on page 6). Others have contributed in significant ways to this endeavor. Curator Susan Goodman has made a wonderful selection of works, and through her special knowledge of Russian Jewish artists has wisely brought the Pen works into the show. My colleagues at the Russian museums – Valentin Rodionov, General Director of The State Tretyakov Gallery in Moscow; Vladimir Gusev, Director, and Dr. Evgenia Petrova, Vice Director of The State Russian Museum in St. Petersburg; Vladimir Prokoptsov, Director of the State Art Museum of the Republic of Belarus in Minsk; and Dr. Olga Akunevich, Director of the Vitebsk Regional Museum – have been most cooperative in allowing works from their institutions to travel abroad. Tamara Grodskova, Director of the State Art Museum of Saratov, Tatiana Kondratenko, Director of the Krasnodar Art Museum, and Natalya Shutskaya, Director of the Regional Picture Gallery in Vladivostok, have generously agreed to the loan of works by Chagall, and cooperated with Michail Cherepashenitz, Acting Deputy Director of the State Museum and Exhibition Centre "ROSIZO", to bring these works to the exhibition. I would also like to thank Dr. Mikhail Shvydkoy, Deputy Minister of the Ministry of Culture of the Russian Federation, and Anna Kolupaeva, Head of its Museum Department, for their support and assistance in connection with this exhibition. I deeply appreciate their collaboration with The Jewish Museum. Thanks to Bella and Meret Meyer, granddaughters of Marc Chagall, who have once again graciously shared with the Museum's staff their particular knowledge and understanding of these works, and Nicolas Iljine, European Representative for the Solomon R. Guggenheim Foundation, who brought the whole project to the Museum's attention. I thank Deputy Directors Ruth Beesch and Thomas Dougherty and all of the staff at the Museum who work to make these exhibitions memorable for their beauty and brilliance. Finally, I thank the Board of Directors, headed by Robert Hurst, Chair, for enabling the Museum to realize its ambitious, diverse, and internationally recognized exhibition program.

Joan Rosenbaum
Helen Goldsmith Menschel Director

ACKNOWLEDGMENTS

Anyone fortunate enough to have visited the great art museums of St. Petersburg and Moscow knows the immense riches of the collections in Russia, but never before has an American audience been able to see, on its own shores, works from these institutions by one of Russia's most important sons. This exhibition, with works created by Marc Chagall during his early years in Russia, brings to the United States the sources that nourished the artist's creativity during his entire life.

The Jewish Museum first learned of the possibility of mounting an exhibition of these works from Nicolas Iljine, European Representative for the Solomon R. Guggenheim Foundation. We acknowledge his effort and skill in coordinating the many elements in Russia necessary to bring the project to a successful conclusion.

The exhibition could not have been realized without the cooperation of many people in Russia. On behalf of The Jewish Museum, I would like to join Joan Rosenbaum in expressing our appreciation to the State Tretyakov Gallery in Moscow and The State Russian Museum in St. Petersburg, two preeminent museums that have so graciously agreed to share their Chagall treasures with an American audience. We thank Tania Gubanova, Curator in Chief, Foreign Department of The State Tretyakov Gallery, and Dr. Evgenia Petrova, Vice Director of The State Russian Museum, and Curator Inna Cholodova of the Vitebsk Regional Museum for their efforts on behalf of their institutions. We also recognize the efforts of Michail Cherepashenitz, Acting Deputy Director of "ROSIZO," who assumed the responsibility of gathering works from Russian provincial museums. In addition we are extremely grateful to art expert Faina Balakhovskaya for her invaluable assistance in connection with the realization of loans from Belarus and Moscow.

The efforts of many Jewish Museum colleagues and associates were needed to maneuver through the complicated process of contract preparation, arranging loans of artworks from Russia, and organizing and writing the catalogue. I especially wish to thank Ruth Beesch, the Deputy Director for Program, for her wise advice and adroit management of the numerous administrative issues that arose. Christine Byron, former Registrar and Collections

Manager, and her staff, including Judith Geis, Associate Registrar, skillfully handled the many detailed arrangements necessary for collecting, shipping, and insuring the exhibition. Claire Orenduff worked tirelessly to coordinate details of the exhibition and catalogue. Sally Lindenbaum performed varied invaluable tasks with calm and cheer, and Yocheved Muffs graciously assisted in the research and details of the catalogue. Amy Gotzler and Emily Magid were helpful with many of the early tasks related to exhibition preparation. We also received editorial assistance from Seth Fogelman, administrative assistance from Jody Heher, and occasional, timely help with our Russian correspondence from Nikolay Silenko, Valeriy Ognev, and Sabena Avanesova.

My sincere appreciation goes to the authors of the catalogue texts, Dr. Aleksandra Shatskikh and Dr. Evgenia Petrova, for applying their considerable knowledge and expertise on Chagall to illuminate the art in the exhibition. Their Russian texts were skillfully and gracefully translated by Galya Korovina and Marian Schwartz. I would like to thank William Zeisel for his intelligent and sensitive editing of the catalogue; it was a pleasure to work with him. Dan Giles of Third Millennium Information and his able staff addressed the logistics of catalogue publication with expertise and efficiency. The book's elegant design was provided by Matt Shelley. Catharine Walston and Honeychurch Associates, Cambridge, copyedited the text. Lana Hum's exhibition design nicely integrates the works of art within the frame of Chagall's life.

I would like to acknowledge the invaluable contributions of numerous other colleagues at The Jewish Museum and their staffs, whose expertise and advice were critical to the realization of this exhibition: Marilyn Davidson, Manager of Product Development and Licensing; Debbie Schwab Dorfman, Director of Merchandising; Tom Dougherty, Deputy Director for Finance and Administration; Jeffrey Fischer, Director of Development; Al Lazarte, Director of Operations; Linda Padawer, Director of Special Events; Grace Rapkin, Director of Marketing; Marcia Saft, Director of Visitor and Tourist Services; Anne Scher, Director of Communications; Deborah Siegel, Director of Membership and Annual Giving; Michael Sittenfeld, Manager of Curatorial Publications; Fred Wasserman, Associate Curator; Aviva Weintraub, Director of Media and Public Relations; Elana Kamenir, Director of Program Funding; Stacey Zaleski, Buyer; and Carole Zawatsky, Director of Education.

Finally, I would like to acknowledge the unfailing support of Joan Rosenbaum, The Jewish Museum's Helen Goldsmith Menschel Director, whose belief in the exhibition's importance was a constant source of encouragement. Her vision and guidance made it possible to realize this project.

Susan Tumarkin Goodman
Senior Curator-at-Large

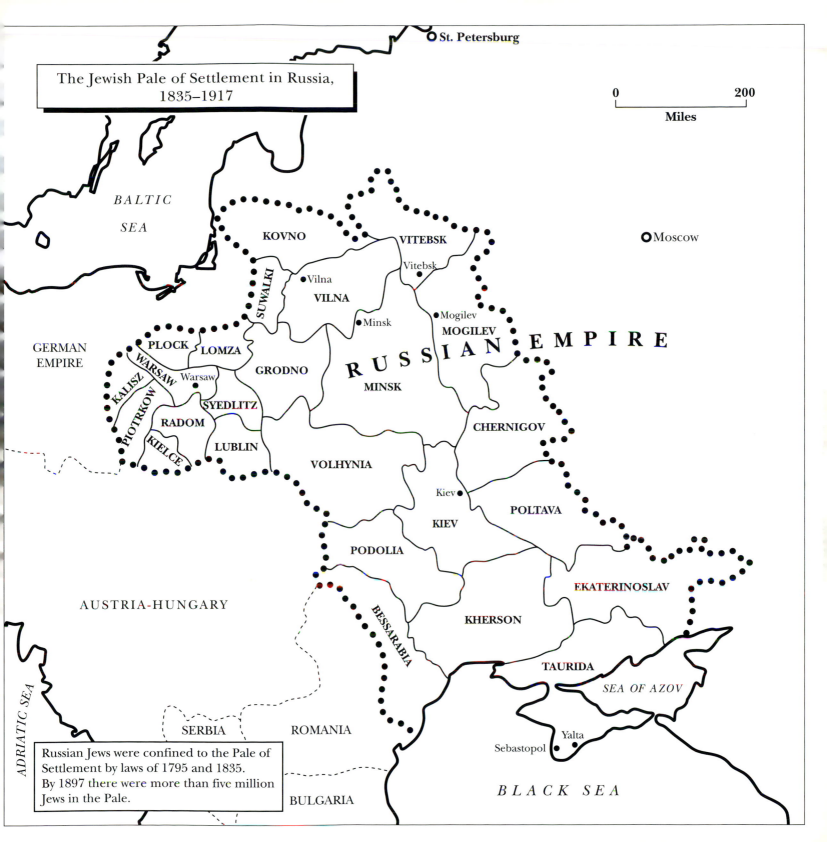

The Jewish Pale of Settlement in Russia,
1835–1917

0 200
Miles

○ St. Petersburg

BALTIC

SEA

○ Moscow

KOVNO

VITEBSK

Vitebsk

SUWALKI

Vilna

VILNA

Minsk

Mogilev

MOGILEV

GERMAN
EMPIRE

PLOCK

LOMZA

R U S S I A N E M P I R E

WARSAW

KALISZ

Warsaw

GRODNO

PIOTRKOW

SYEDLITZ

MINSK

RADOM

KIELCE

LUBLIN

CHERNIGOV

VOLHYNIA

Kiev

POLTAVA

AUSTRIA-HUNGARY

KIEV

PODOLIA

EKATERINOSLAV

BESSARABIA

KHERSON

ADRIATIC SEA

TAURIDA

SEA OF AZOV

SERBIA

ROMANIA

Yalta

Sebastopol

BULGARIA

BLACK SEA

Russian Jews were confined to the Pale of
Settlement by laws of 1795 and 1835.
By 1897 there were more than five million
Jews in the Pale.

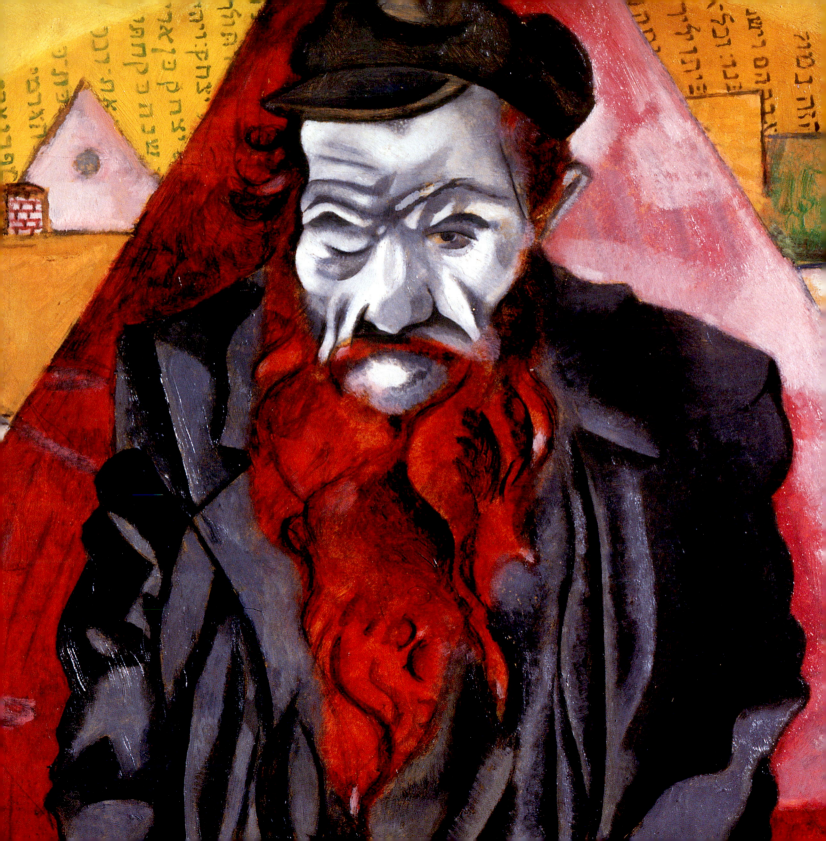

CHAGALL'S PARADISE LOST
THE RUSSIAN YEARS

Susan Tumarkin Goodman

Why do I always paint Vitebsk? With these pictures I create my own reality for myself, I recreate my home.

MARC CHAGALL

How did Marc Chagall invent images that have captured the imagination of Western society, becoming part of our artistic imagination and visual language? The answer lies in his years in Russia, where he developed a powerful visual memory and a pictorial intelligence not limited to a mere configuration of his Russian life and environs. Chagall's vision soared and he created a new reality, one that drew on both his inner and outer worlds. The images and experiences from his early years in Vitebsk sustained Chagall's art for more than seventy years, both when he lived in Russia (1887–1910, 1914–22) and in subsequent years when he lived abroad. His anti-rational conception of painting led him to create not a sentimental, picturesque Vitebsk, but a phantasmagorical city, viewed through the filter of his mind.

It is true that his first major public recognition as an avant-garde painter occurred far from Russia, in Paris, yet even there his art dealt with images and themes from his life as a Russian Jew. Absorbing Fauvist color and Cubist faceting and blending them convincingly with his own folk style, Chagall gave the grim life of Hasidic Jews in Vitebsk the romantic overtones of a charmed world. Combining aspects of Modernism with his unique artistic language, Chagall caught the attention of European critics, collectors, and an art-loving public.

It seems astonishing that a boyhood in a Russian provincial town could have been sufficiently complex and textured, and afforded enough imaginative stimuli, to result in nearly one hundred years of Chagall's treasure of images. That it did owes much to the nature of Russian society at the turn of the twentieth century, and in particular, to the role of Jews, one of the country's most numerous and creative minorities.

Opposite: Detail from Plate 39. *Jew in Bright Red*, 1915

THE AMBIGUITIES OF A DUAL IDENTITY

Chagall's art can be understood as the response to a situation that has long marked the history of Russian Jews. Though they were cultural innovators who made important contributions to the broader society, Jews were considered outsiders in a frequently hostile society. In the years immediately after 1881, in particular, following the assassination of Tsar Alexander II by revolutionary terrorists, a wave of physical attacks on Jews swept parts of Russia. The choice for Jews there was whether to respond to the ambient hostility through acculturation or by asserting their Jewish identity.

The ambiguities of being Jewish in Russia were well established by the time of Chagall's birth. For religious and economic reasons, from the late-eighteenth century to the middle of the First World War, the Russian state forbade most Jews from moving out of the area known as the Pale of Settlement (which comprised parts of modern Ukraine, Belarus, Poland, and the Baltic States) and living among the ethnic Russian population. Jews in the Pale lived primarily within the confines of a Jewish community and met non-Jews only for purposes of commerce or official business.[1] Separation was a hardship for those Jews who sought to participate in the broader world, but not necessarily for those who wanted to preserve the traditional style of life and belief. In the *shtetl*, the market town indelibly associated with Russian Jewish life and culture, a truly observant Jew would have rejected the value of the *Haskalah* (Jewish Enlightenment). There, if secular culture and philosophy became core values, they threatened the religious ambience that seemed central to Jewish identity. Chagall himself was born of a family steeped in religious life: his parents were observant Hasidic Jews who found spiritual satisfaction in a life defined by their faith and organized by prayer.

Jewish artists of the period, like Jews in general, had two basic alternatives for living with the uncertainty of their situation. One was to hide or deny one's Jewish roots in order to be able to rise in the Russian art world. For example, Mark Antokolsky, Isaak Levitan, Leonid Pasternak, and Leon Bakst, among others, moved away from public expressions of Jewishness when confronted with entrenched, overt, and pervasive discrimination. The other artistic alternative, and the one that Chagall chose, was to cherish and publicly express one's Jewish roots by integrating them into his art – a decision that was not solely a matter of religious or philosophical preference, but also a form of self-assertion and an expression of principle. Reflecting one's Judaism in art entailed coping with the discrimination and anti-Semitism that were endemic to tsarist Russia. Thus, Chagall's mother used bribes to circumvent the rule forbidding Jewish children to go to state schools, and years later Chagall himself was briefly imprisoned for living in St. Petersburg (to study painting) without the proper residency permit.

A true resolution of the situation for Jews could only come in a reformed Russia that accepted them as full citizens and removed restrictions on their personal and civil rights. Most Russian Jews welcomed the Revolution in 1917, which promised to end tsarist oppression. Chagall was among those who rejoiced and fully supported the new regime. But the productive period ended relatively quickly, and within five years the Soviet government tightened controls over culture and began imposing a state-controlled concept of art. Chagall and many other

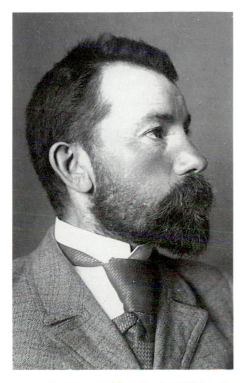

Fig. 1. *Yehuda Pen*, 1905, Collection Hillel and Lola Kasovsky, Jerusalem

talented avant-garde artists saw no option but to leave the country.

By that time, traditional Jewish life was also disappearing. War had displaced nearly a million Jews from their homes and destroyed what remained of *shtetl* culture, which had defined much of Eastern European Jewish life for centuries.[2] This completed a process that had begun during the nineteenth century, when improved communications and economic changes started transforming traditional Jewry by providing a broader and more cosmopolitan perspective. The fading of traditional Jewish society left artists like Chagall with powerful memories that could no longer be fed by a tangible reality. Instead, that culture became an emotional and intellectual source that existed solely in memory and the imagination. The artist could take his vision with him and transform it endlessly, whether he lived in the Soviet Union or thousands of miles away. This was not new for Chagall, who had carried his imaginary Vitebsk to St. Petersburg and to Paris. In those early days he could return to the source of his inspiration and touch it again, drawing yet more from it. Now that it was gone, he could go home only in his head and his art. So rich had the experience been, it sustained him for the rest of his life (he died in 1985). We must therefore look at this experience more closely, through his words and, most of all, his art.

BECOMING AN ARTIST IN THE PALE

"I want to be a painter," the young Chagall told his mother, who did not comprehend her oldest child's interest in art or understand why he would choose a vocation that seemed so impractical. Perhaps if Chagall were living in a small village, his desire would have remained only an unfulfilled fantasy, but in Vitebsk it could be made reality, and the young man knew exactly how. "There's a place in town; if I'm admitted and if I complete the courses, I'll come out a regular artist. I'd be so happy!" The place was a studio on Gogol Street identified by a large blue sign that bore the words, in white, "The Artist Pen's School of Drawing and Painting" (Fig. 1).[3]

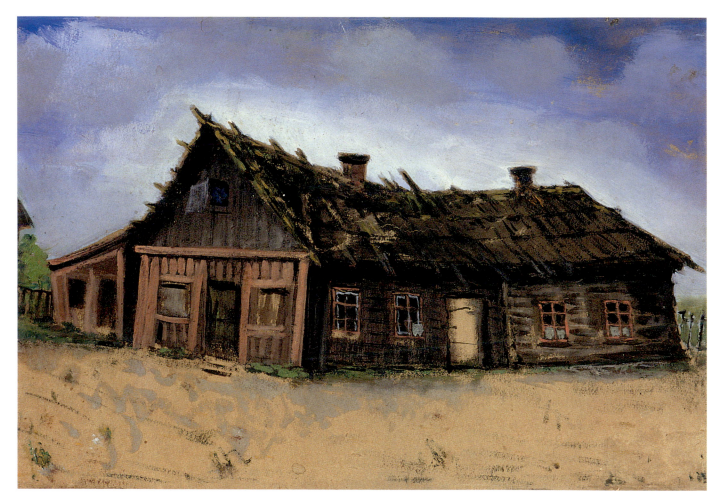

Plate 3. Yehuda Pen
House Where I Was Born, 1886–90

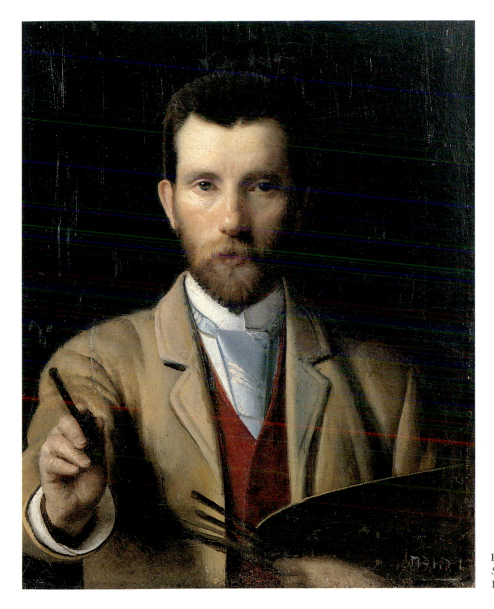

Plate 4. Yehuda Pen
Self-Portrait with Palette,
1898

Fig. 2. *Vitebsk,
Zamkovaya Street with
View of Cathedral,*
postcard, early
twentieth century.
Private Collection,
Moscow

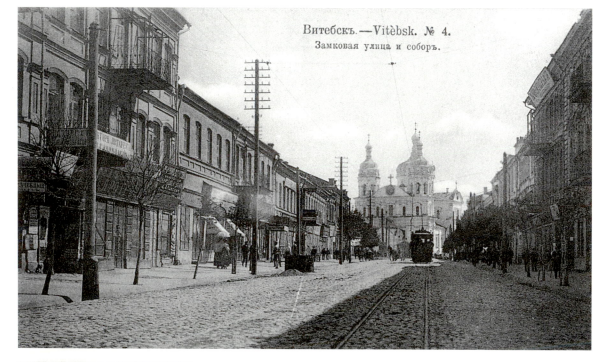

Fig. 3. *Yehuda Pen with
Female Students,* c. 1910.
Private Collection, Moscow

Yehuda Pen is now known primarily for the fact that he was Chagall's first teacher and his initial artistic influence.[4] He was born in 1854, in the provincial town of Novo-Alexandrovsk, and raised in surroundings steeped in traditional Jewish practice. Pen depicts the simple wooden dwelling where he was raised in *House Where I Was Born* (Plate 3). His passion for drawing did not meet with approval from his family, but with the encouragement of another student he managed nevertheless to gain admission to the prestigious Imperial Academy of Art in St. Petersburg. He was one of a small group of young Jews who was accepted in part because of the precedent set by the sculptor Mark Antokolsky a generation earlier.

As a result of his graduation and receipt of an advanced degree, Pen was entitled to live wherever he wanted, a privilege denied to most other Jews. On the advice of interested patrons, he moved to Vitebsk, where in 1897 he was encouraged to open a private art school. It was the first, and for some time, the only Jewish art school in the Pale. Vitebsk was the metropolis of an economically developed part of the Pale and was known to be a major cultural center (Fig. 2). More than half of its approximately 60,000 residents were Jews, who enjoyed professional opportunities that were not open to them in Moscow or St. Petersburg. Here in a provincial town, far from the centers of imperial power and Russian culture, it was possible for Jews to participate relatively freely in the various activities of the city's social and professional life.

Pen had not initially intended to focus on Jewish art, although he considered himself a Jewish artist and was regarded as one by friends and associates (Plate 4). Since most of the town's population was Jewish, and the majority of Pen's students spoke only Yiddish, the school's emphasis was naturally Jewish.[5] While Pen observed Jewish law, and classes were not held on the Sabbath, the unique quality of the school was determined by the strong personal relationship that the teacher had with his students. He imbued them with the sense that it was possible to be a practicing Jew and also an artist. As Chagall, his pupil, once commented, "Had I not been a Jew, I would not have been an artist or else I would have been an entirely different artist."[6]

Next to painting, teaching was the most important of Pen's activities. Because of his own difficult childhood and youth, Pen was intent on encouraging anyone in whom he sensed even the slightest artistic talent (Fig. 3). He organized his instruction along academic lines, including lessons in drawing plaster casts and copying academic drawings, as well as working with a model and rendering a still life or studies from nature. Pen covered the walls of his apartment-studio with paintings, some of them his own works and others by students, and effectively operated the city's leading painting gallery and museum.

As a painter, Pen selected his subjects from the immediate Russian Jewish world. He focused on domestic views and often tied his genre paintings to specific households or religious situations. His most prevalent types, devout Jews, craftsmen, and citizens of the town, tend to be portrayed in their characteristic surroundings, depicted in obsessive detail but with the Jewish mode of life and its attributes metaphorically transformed.[7] In *The Clockmaker* (Plate 5) he describes the workspace with as much precision as the figure of the watchmaker, whose position, surrounded by clocks, suggests either a psychological state or a symbol of the flow of time or history. Pen usually showed men engaged in their occupations, whereas women were

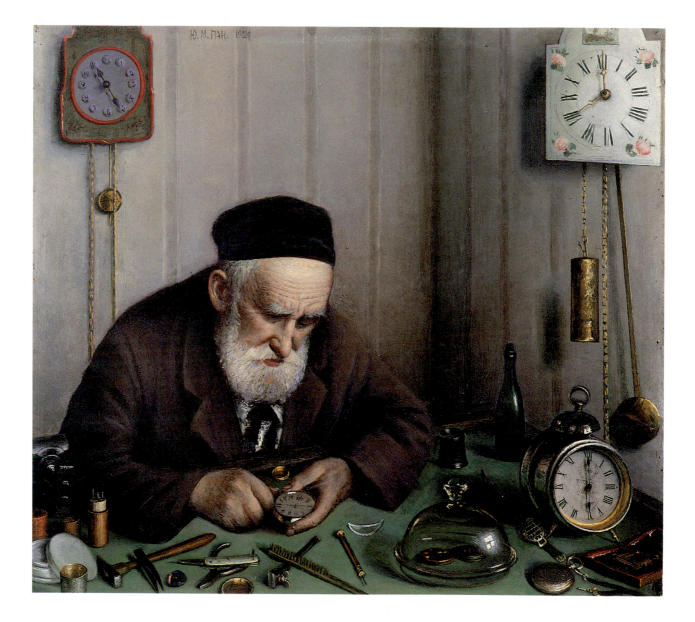

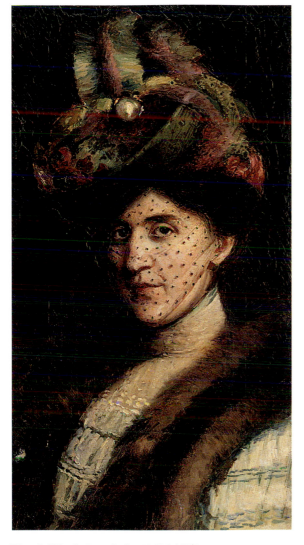

Plate 6. Yehuda Pen, *Lady with Veil*, 1907

Opposite: Plate 5. Yehuda Pen, *The Clockmaker*, 1924

singled out only for the beauty of their female form. The provincial types depicted in *Lady with Veil* (Plate 6), *Portrait of a Young Man* (Plate 7), and *Reading a Newspaper* (Plate 8) often remain anonymous and lack individual identity except for their defining attributes.

Pen's admiration for earlier European genre and Old Master portrait paintings can be seen in various works, including *Self Portrait in a Straw Hat* (1890) and *The Clockmaker*, as well *Letter from America* (Plate 9).[8] Text performs an important literary role in the expression of a theme, as in *Letter from America* (1903), where the letter appears to have been read and returned to its envelope, with only the title of the painting to hint at its contents.[9] The work alludes to the ties between Jews living in tsarist Russia and North America, where they had emigrated *en masse* since the end of the nineteenth century. Text again helps define the image in *Reading a Newspaper*, where the figure is perusing an editorial in *Der Fraind*, a secular Yiddish publication that would have appealed to Jews with more cosmopolitan interests.

Pen frequently took his students into the countryside of Vitebsk to draw and paint. The picturesque landscape offered an inexhaustible source of motifs and subjects for *plein-air* works, a love of which he carefully fostered in his students (*Barn on the Vitba*) (Plate 10). Vitebsk sits on high banks where three rivers meet, and *Water Tower Near the Prison (Water Pump on Surozkaya Road)* (Plate 11), with its untrammeled depiction of nature, could be considered to have a leisurely appearance. Pen remained true to the landscape but animated it by portraying vistas in a fore-shortened manner – from above, as in *Circus Lerri* (Plate 12), or below, as in *Bathing a Horse* (Plate 13), where he sought to capture the momentary effect rather than the details.

Pen also painted his own portrait, usually with the attributes

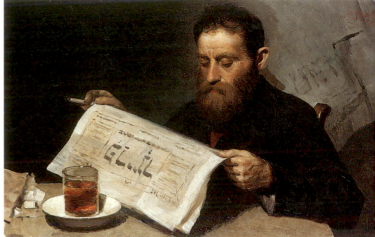

Plate 8. Yehuda Pen
Reading a Newspaper, c. 1910

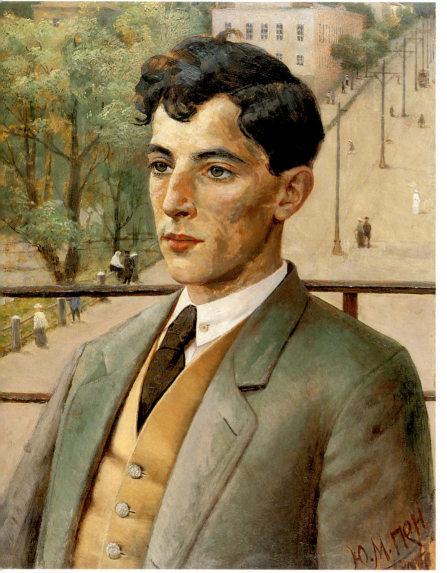

Plate 7. Yehuda Pen
Portrait of a Young Man, 1917

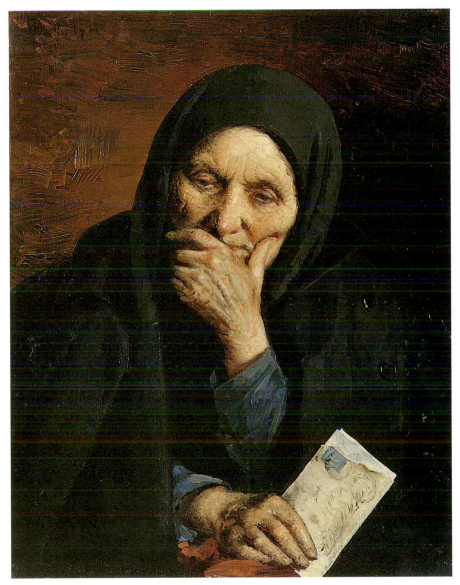

Plate 9. Yehuda Pen
Letter from America, 1913

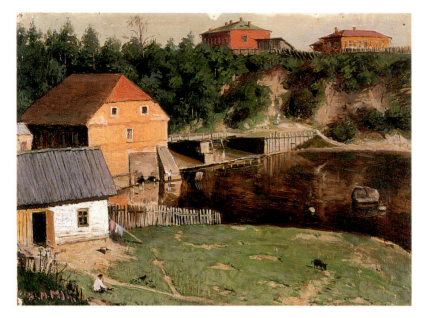

Plate 10. Yehuda Pen
Barn on the Vitba, c. 1910

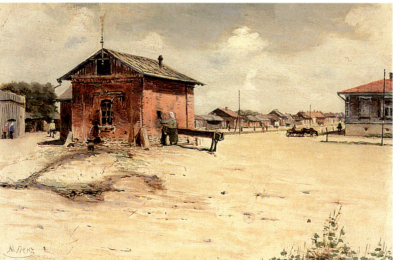

Plate 11. Yehuda Pen
*Water Tower Near the Prison
(Water Pump on Surozkaya Road)*, c. 1910

of a successful artist. Earlier self-portraits depicted the young man as something of a dandy, (see Plate 4) but *Self-Portrait, Breakfast* (Plate 14), created at the age of 75, presents a wise old man, within the setting of his own school, sitting in front of a dish overflowing with potatoes that represent the fullness of life. It has been suggested that *Self-Portrait, Breakfast* offers clues about the artist through the name of the newspaper on the table in front of him, *Vitebsk Proletarian,* a term used by Pen to describe himself.[10]

By observing Pen practicing his craft, the young Chagall learned early on that Jewish themes were legitimate artistic subjects. Equally important, although Chagall actually attended Pen's school for only a few months and learned little about technique, he was introduced both to modern art and, through the Berlin periodical *Ost und West,* to the world of modern Jewish Art.[11] This was crucial for Chagall's artistic development, because he grew up in an intensely religious atmosphere that permeated every aspect of life, where the emotional exultation of Hasidic Judaism gave the world an almost hallucinatory dimension (Fig. 4). However, the religiosity of Chagall's home existed within the larger universe of Vitebsk, which offered glimpses of Russian and Western European culture. At home the family conversed in Yiddish, the predominant language spoken by Ashkenazi Jews in the Pale, but Chagall and his siblings

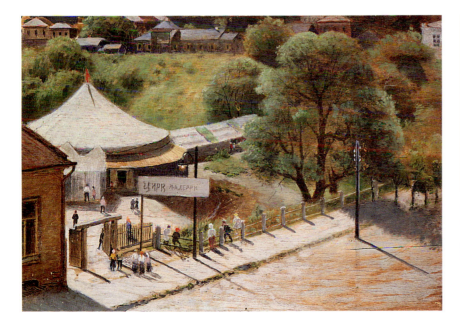

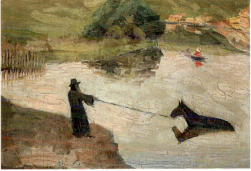

Left: Plate 12. Yehuda Pen
Circus Lerri, 1900–10

Above: Plate 13. Yehuda Pen
Bathing a Horse, c. 1910

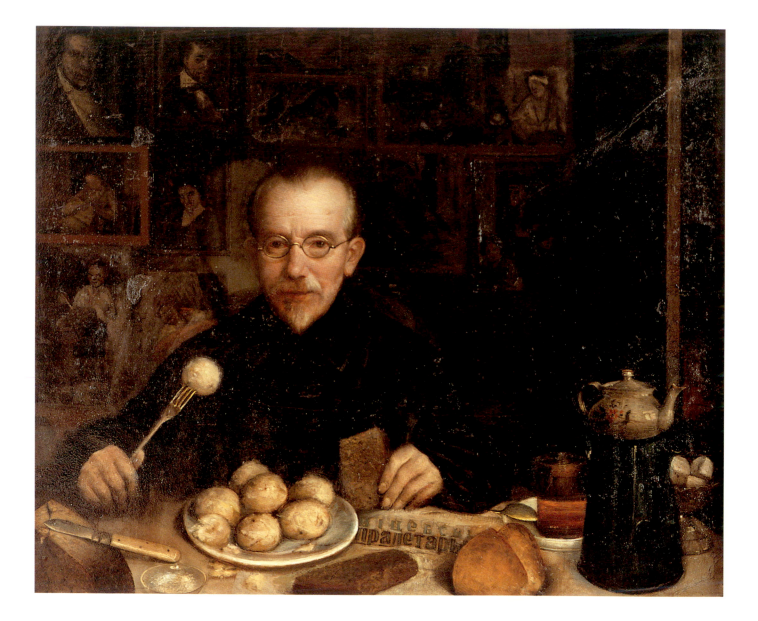

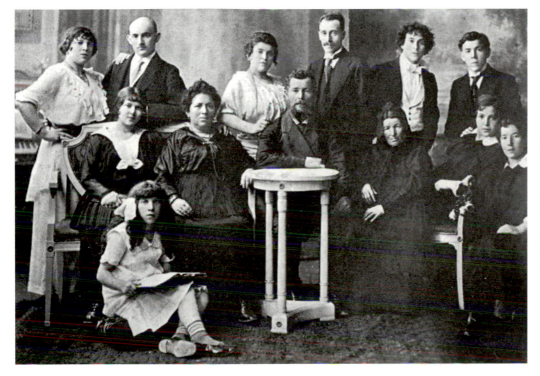

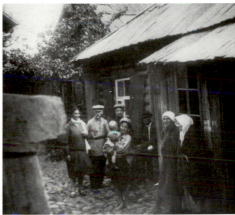

Opposite page: Plate 14. Yehuda Pen
Self-Portrait, Breakfast, 1929

Left: Fig. 4. *Marc Chagall (second from right
standing) with parents, brothers and sisters
and relatives in Vitebsk*, 1908–09.
Ida Chagall Archives, Paris

Above: Fig. 5. *Photo of Yehuda Pen and
neighbors in the backyard of Chagall's parents'
house*, 1928. Ida Chagall Archives, Paris

spoke Russian with their friends. The young Chagall would even wander into churches to view the icons and stained glass windows.

Chagall's highly personal and idiosyncratic style soon distinguished itself as almost a direct refutation of Pen's more academic vision, yet he celebrated his teacher with great respect and affection in succeeding years. Writing in 1921, on the occasion of the twenty-fifth anniversary of Pen's activity in Vitebsk, he recalled how, "as a boy, I climbed the steps of your studio. And the tremor with which I awaited you: you were to decide my fate in my mother's presence, just as you have decided the fate of so many other young boys from Vitebsk and the whole province."[12] Although Chagall rejected Pen's naturalism and came to hold completely different artistic values than his teacher, he was grateful to his mentor. He shared his admiration with many of Pen's students, including El Lissitzky, Ossip Zadkine, Solomon Yudovin, Oskar Meshchaninov, and Abel Pan, who were later recognized as major artists in Russia and abroad (Fig. 5).

A LARGER WORLD BECKONS

Chagall followed Pen's early example, and on the urging of Victor Mekler, a fellow student at Pen's school, ventured to the Russian capital in 1908 (Fig. 6). Mekler's influence on Chagall's life was significant; he came from an affluent Jewish family in Vitebsk, where he introduced the young artist into a cultured middle-class circle of Jewish youth.

The St. Petersburg years were formative for Chagall (Fig. 7). The city was known as a meeting place for vigorous young Russian artists who were proponents of new European movements, especially those based in Paris, such as Expressionism, Symbolism, Fauvism, and Cubism. Debates were raging about modern painting and the need to overthrow traditional artistic concepts. Chagall, the provincial student, must have been fascinated by these turbulent developments, which would have fostered his inclination to explore new forms of personal expression.

Among the array of teachers with whom he studied was another Jew, Leon Bakst, who directed the Zvantseva School, then the most progressive art school in Russia. A year and a half of study at the school again had scant effect on Chagall's style or technique, but it did encourage him to explore Modernism and look toward Paris for artistic inspiration.

Most of Chagall's descriptions of the St. Petersburg years reflect a feeling of unease in the presence of the influential rich Jews of Russia's capital. He met individuals whose Jewish roots were still central as well as those trying to acculturate into Russian Christian society, but he was not entirely comfortable with either group. During 1908–10, he lived very poorly, always engaging in various schemes in order to remain in the capital. His nostalgia for his own town is expressed in a 1908 painting, *The Window* (Plate 15), the earliest extant work by Chagall that remains in Russia. It illuminates the process of artistic transition between

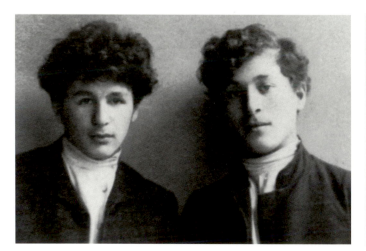

Fig. 6. *Chagall (right) and Victor Mekler while Pen's students*, 1906. Ida Chagall Archives, Paris

Fig. 7. *Chagall as a student of "The Imperial Society" in St. Petersburg*, 1910. Ida Chagall Archives, Paris

Plate 15. *The Window,* 1908

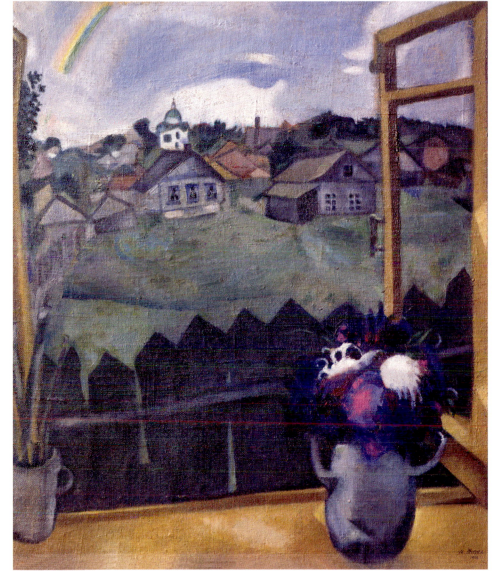

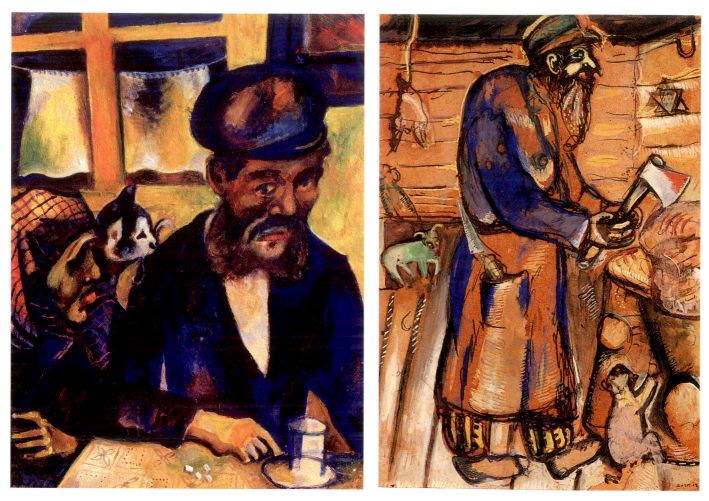

Plate 16. *My Father*, 1914 Plate 17. *Butcher (Grandfather)*, 1910

Chagall's study under Yehuda Pen in Vitebsk and his works thereafter.[13] At this early stage the artist is aware of the simple structures of his town, with its monastery, churches, and synagogues crowded together with the dome of a cathedral dominating the view.

Chagall began to focus his art on his close family, which he had left behind in Vitebsk, through a series of family portraits. An expressionist portrayal of his father and grandmother in the painting *My Father* (Plate 16) captures the tragedy and weariness of his father's life of toil. Zachar's taut, drawn face has the serious mien of a man who had spent many hard decades laboring in a herring warehouse. Chagall relates that as a boy he wanted desperately to escape the drabness and drudgery of his father's colorless life. His mother, Feiga-Ita, was by contrast a lively, strong-willed woman who made the major family decisions. She ran a small shop, represented in *The Shop in Vitebsk* (Plate 18), managed stores, and rented out small houses. Sugar and flour, along with fish and brightly decorated canisters, adorn the space in her shop, creating an extension of home and providing a means for Chagall to celebrate his roots.

Chagall's most adored relative was his maternal grandfather, a butcher from

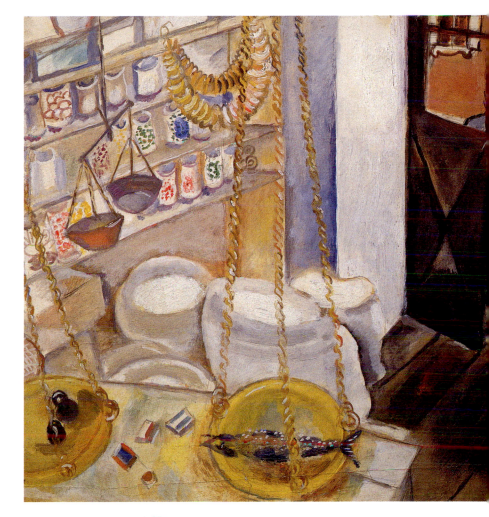

Plate 18. *The Shop in Vitebsk*, 1914

Fig. 8. *Chagall with Bella Rosenfeld*, 1910.
Ida Chagall Archives, Paris

Plate 19. *Lovers in Black*, c. 1910

the neighboring town of Lyozno, with whom he spent vacations. The portrait *Butcher (Grandfather)* (Plate 17) shows the old man intent on his work, in distorted perspective with upended floor and an incongruous little green goat. The Star of David on the wall indicates his role is that of ritual slaughterer to the Jewish community, where his mundane job is ennobled by a higher spiritual sensibility.

During the autumn of l909, a new personage entered Chagall's universe. Bella Rosenfeld was the daughter of a wealthy Jewish jeweler from Vitebsk. *Lovers in Black* (Plate 19) conveys Chagall's longing for Bella, and it foreshadows later versions of paintings of lovers that achieve emotional effect through a predominant color. Bella had returned from Moscow, where she attended an exclusive private girls' school and studied with the well-known theater director Konstantin Stanislavsky. Her family had grave misgivings about her interest in the young painter, who seemed decidedly bohemian. But the couple's love became an inexhaustible source of artistic inspiration for Chagall, who celebrated it in paintings for years to come (Fig. 8).

FAME IN PARIS

During the spring of l910, Chagall's foremost teacher, Leon Bakst, left St. Petersburg for Paris to join Sergei Diaghilev's ballet company. Chagall also felt the desire to visit the art capital of Europe. In exchange for a single painting and one drawing, his patron, Maxim Vinaver, offered Chagall a stipend that enabled him to spend almost four years in Paris. And it was here, in the years before World War I, that he developed his unique style.

From far away, the dullness, poverty, and religious devotion of the Hasidic Jews in Vitebsk took on the romantic overtones of the picturesque. Chagall's profoundly Russian and Jewish roots and the formative experiences of his childhood fused with the most modern artistic currents to form a style that relied less on direct perception than on imagination and memory. *Study for "Rain"* (Plate 20) creates a world where the law of gravity is suspended and chaos reigns. A house is being lifted from its foundation, while a goatherd and his charge walk in space against a darkened sky. The individuals featured in *The Musicians*

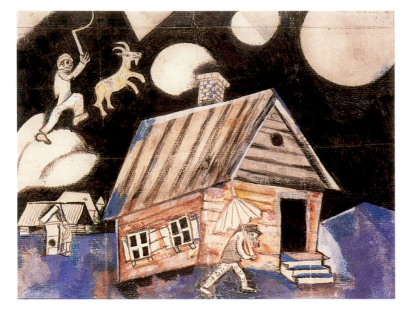

Plate 20. *Study for "Rain"*, 1911

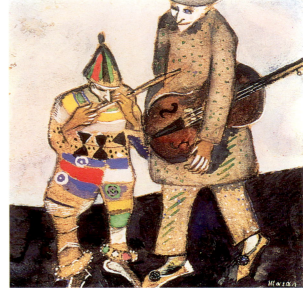

Plate 21. *The Musicians*, 1911

(Plate 21) also exist in an unreal space, freed from any earthly references to time and place. Their personal attributes, a flute and violin, give them the appearance more of circus entertainers than serious musical performers, an impression underlined by the harlequin costume of the flautist and the spatial distortion. Nostalgia for his Hasidic roots is at the core of *The Jewish Wedding* (Plate 22), which contrasts the rapturous spirit and exaggerated gestures of the dancing couple with the sedate pose of the wedding couple, attired in Western clothing, who seem removed from the uninhibited behavior of the dancers.

The advanced and original works that Chagall created in Paris led him to be known and respected by the leading figures of the European avant-garde. In 1913, Guillaume Apollinaire arranged for Herwarth Walden, the influential German art dealer and champion of Expressionist art, to visit Chagall's studio in Paris. He was sufficiently impressed to offer Chagall a one-person exhibition at his Berlin gallery, *Der Sturm*, in spring 1914. When Chagall traveled to Berlin for his exhibition, he was at the zenith of his early career, but he longed for Bella. He had been away from Vitebsk for four years, and as time passed their letters were becoming increasingly remote. Fearing that if he remained abroad any longer he would lose her, he returned to Russia in June 1914 for what he expected to be a brief visit.

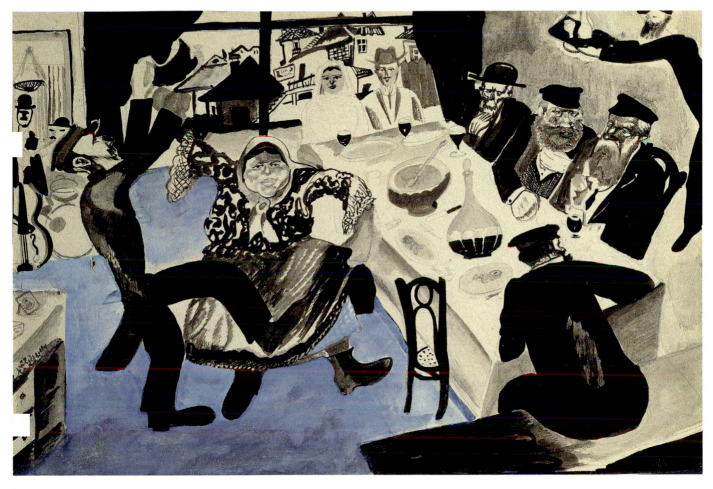

Plate 22. *The Jewish Wedding*, c. 1910

RETURN TO RUSSIA

Chagall's second period in Russia spanned eight years marked by events of great magnitude that affected the life of every Russian. Shortly after his arrival, the outbreak of war in Europe prevented travel across borders and confined him to Russia. He had no visible means of support, since all of his new works were still in Berlin and had never been shown in Russia.

Once he adjusted to the notion that he might be in Russia for the duration of the war, Chagall began to paint. He started with a series of self-portraits. *Self-Portrait at the Easel* (Plate 2) reveals his introspection and reflects the process of the artist coming to terms with himself and his roots. How different it is from Yehuda Pen's *Portrait of Marc Chagall* (See Plate 1), a straightforward image of the dapper twenty-three-year-old artist at the peak of his reputation. Just as Chagall had come to accept his new physical surroundings, he also had to reorient his artistic and personal direction. The self-portrait's placement of the artist before a blank canvas, dressed in a performer's costume, suggests a process of personal reinvention.

Initially, Chagall was completely captivated by the physical reality of his native environment, which his memory had transmuted into an imaginary world. He now painted everyone and every place that surrounded him, as if trying to document reality. He began to rediscover and record his roots in a series of about seventy paintings and drawings that he called "documents." These fairly straightforward depictions of his family and scenes of Vitebsk register his new impressions and satisfied his longing for the physical reality of his homeland. Chagall's return to a form of painting based on observation of his immediate environs

may have been prompted by the desire to produce works accessible to his family.

One of the most striking aspects of his childhood was Chagall's deep affection for his six sisters and younger brother, David. But tragedy struck when David died young of tuberculosis. In *David with a Mandolin* (Plate 23), Chagall draws a distorted face enhanced with an unnatural cold blue to create a mask shot-through with pain. Quite the opposite feeling emerges from *Mariaska* (Plate 24), which reveals his youngest sister as an expectant mother, her pregnancy highlighted by her full red blouse and the lush plants behind her. *View from the Window, Vitebsk* (Plate 25) reestablishes the artist's roots, and is reminiscent of a similar work from l908 depicting the same view. In both 1908 and 1914, the view from the window of his parents' house remained constant, enabling him once more and with striking accuracy to connect with the reality he remembered.

Beneath Chagall's pleasure in rediscovering his native town lay frustration with being confined to so small a universe after the excitement, freedom, and celebrity of his years in Paris. Indeed, Chagall referred to Vitebsk at this time as a "a place like no other; a strange town, an unhappy town, a boring town."[14] In *Uncle's Shop in Lyozno* (Plate 26), the signs on the front of the buildings reflect a casual neglect, and the shopkeepers seem to relax aimlessly as they converse, surrounded by a pervasive stillness. In *The Barbershop (Uncle Sussy)* (Plate 27), from the same year and painted in similar tones, a freestanding mirror dominates the central wall on which the barber's implements are disposed against a patterned background. Chagall's uncle appears to be in no great hurry as he awaits the arrival of his next customer.

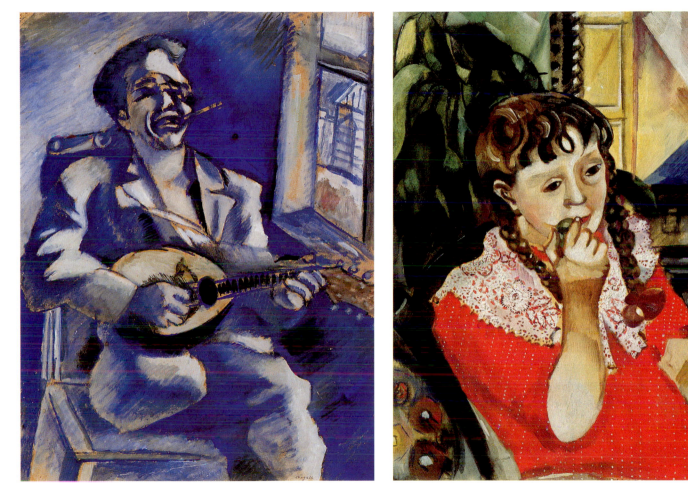

Plate 23. *David with a Mandolin*, 1914–15 Plate 24. *Mariaska (Portrait of Sister)*, 1914–15

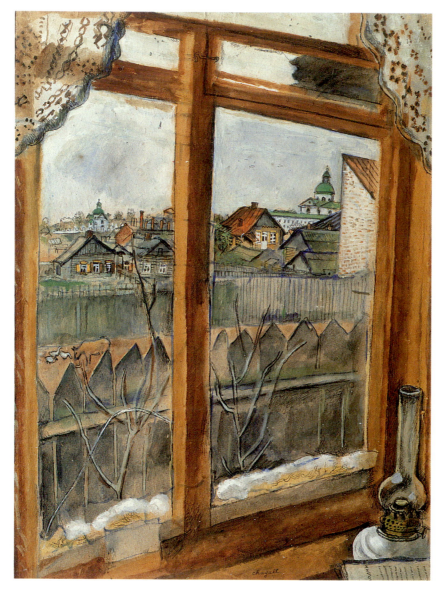

Plate 25. *View from the Window,
Vitebsk*, 1914–15

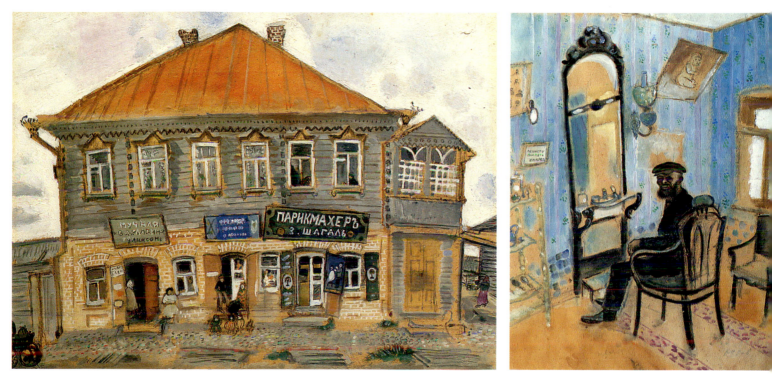

Plate 26. *Uncle's Shop in Lyozno*, 1914

Plate 27. *The Barbershop (Uncle Sussy)*, 1914

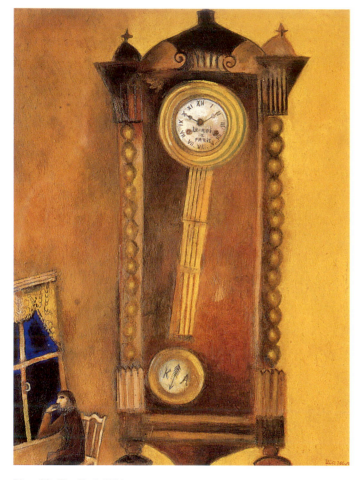

Plate 28. *The Clock*, 1914

Chagall's mood seems most clearly revealed in the painting *The Clock* (Plate 28), in which a timepiece (made in Paris) that hung on the wall of his family's living room marks the slow but continual passage of time. *The Clock* and its pendant, *The Mirror* (Plate 29), convey psychological overtones through everyday objects that symbolize the artist's claustrophobic state of mind. Marc and Bella appear in these paintings as tiny figures, completely out of proportion with the scale of the clock and the mirror, overwhelmed by their objects.

With the onset of World War I, Chagall became less self-absorbed. As the Germans advanced and Jewish refugees moved east, Vitebsk was closer to the front. Chagall was required to enter the military in September 1915, and he used this occasion to create a visual document of the senselessness and horror of war. He created an entire series about soldiers, a familiar sight in Vitebsk, as they streamed through town. Drab colors mark the mood of war in *Soldiers with Bread* (Plate 30), in which Chagall painted two uniformed soldiers, one viewed from the front, the other from the rear. Neither glamorized nor romanticized, the soldiers clutch loaves of bread, clearly a commodity of great value.

Relying solely on ink, pencil, pen, and brush for dramatic effect, Chagall made drawings depicting war victims. In the compressed space of the drawing *War* (Plate 34), a large window frames the figure of an old man whose spirit appears broken. A landscape provides a sweep of history; war has changed the place names that appear to surround the embracing couple, while on the far side soldiers march to the front. In *The Reunion* (Plate 33), black ink with white highlights depict a young woman and her man, a soldier on leave, as well as an old couple, all conveying the trauma

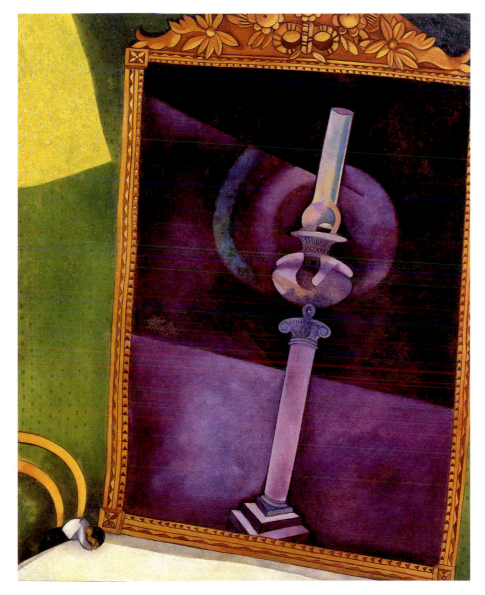

Plate 29. *The Mirror*, 1915

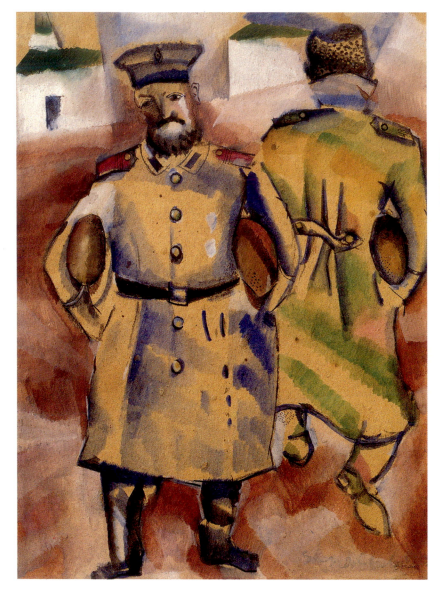

Plate 31. *The Wounded Soldier*, 1914

Plate 30. *Soldiers with Bread*, 1914–15

Plate 32.
Man on a Stretcher, 1914

Plate 33.
The Reunion, 1914

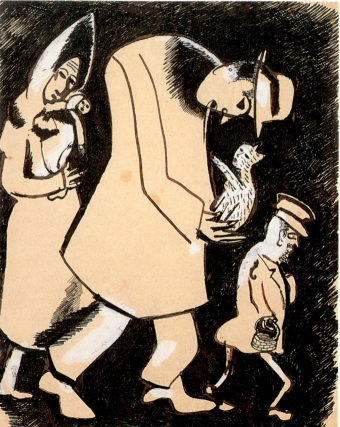

Plate 34. *War*, 1914

Plate 35. *Strollers*, 1914

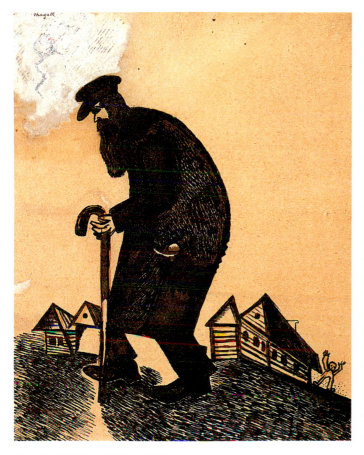

Plate 36. *Old Man with Cane*, 1914

of being forced apart by war.[15] The dramatic effects of *Man on a Stretcher* (Plate 32) and *The Wounded Soldier* (Plate 31) are gained by blackening the paper with thick brushstrokes and sharply contrasting the white areas, which have been left unpainted.

The pitiful sight of refugees torn from their homes impelled Chagall to create a war cycle that reminds us of the particular effect of World War I on the Jews in the Pale of Settlement. The bent and broken people in *Strollers* (Plate 35) and *Old Man with Cane* (Plate 36) cling to the remnants of their worldly goods and the living creatures they have salvaged from destruction.

Chagall's project of documenting Vitebsk merged with the advanced formal concepts of his last two years in Paris in a series of works that address Jewish themes. The winter scene in *Study for "Over Vitebsk"* (Plates 37, 38) naturalistically depicts a major crossroads in Vitebsk: the street lies deserted between the frozen houses, the cubiform church, and St. Ilinskaa Cathedral. Chagall endows reality with a wondrous dimension by including the figure of an old Jew, carrying a walking stick and a beggar's sack, who floats in the sky as if part of the landscape. The figure plays on the Yiddish expression *genen iber di heiser* ("going over houses"), used to describe a beggar moving from door to door. A rendering of a Jewish idiom, it is also an attempt by

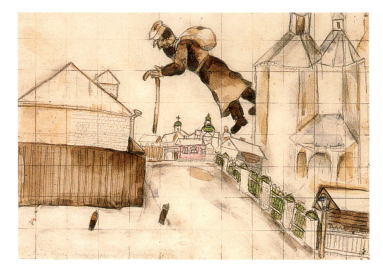

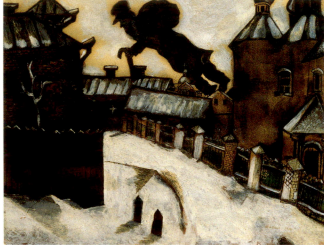

Plate 37. *Study for "Over Vitebsk"*
(Environs of Vitebsk), 1914

Plate 38. *Study for "Over Vitebsk,"* 1914

Chagall to characterize an essential truth about the Jews of Eastern Europe, who had constantly been forced to move.[16] In another work, *Jew in Bright Red* (Plate 39), the artist was motivated by a chance encounter with a Vitebsk beggar. For Chagall, this individual evoked the spirituality of migrant rabbis and holy men who were prevalent in the life of Russia's Hasidic community. The background, composed of Hebrew characters copied with great care from chapters in Genesis, contributes to the image of a learned and devout figure.[17]

Only two months before entering military service, Chagall was able to fulfill his dream of marrying Bella, despite the Rosenfeld family's lack of enthusiasm. This important event, which took place in July 1915 in the home of her parents, was the catalyst for the many paintings in his lyrical lovers' cycle. Chagall had anticipated his bliss in *Lovers in Blue* (Plate 42), completed in the prior year, which expresses the joy experienced by the young couple after their years of separation. This painting, unlike *Lovers in Black*, from 1910 when he lived in Paris, shows the couple enveloped in a blue haze that emanates from within the painting and binds them together. *Lovers in Green* (Plate 66), another 1914 work depicting the couple, is notable for its composition: the figures are inside a circle within a square.

Chagall soon exited from a lover's dream world to an ordinary one filled with images of domestic married life. The newlyweds made trips into the countryside around Vitebsk, where they could gaze at the lush summer

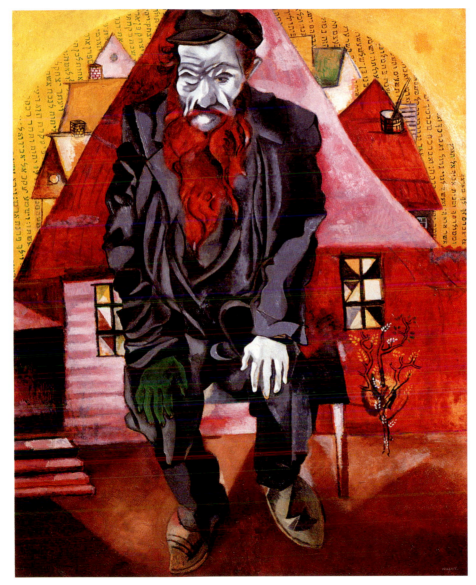

Plate 39.
Jew in Bright Red, 1915

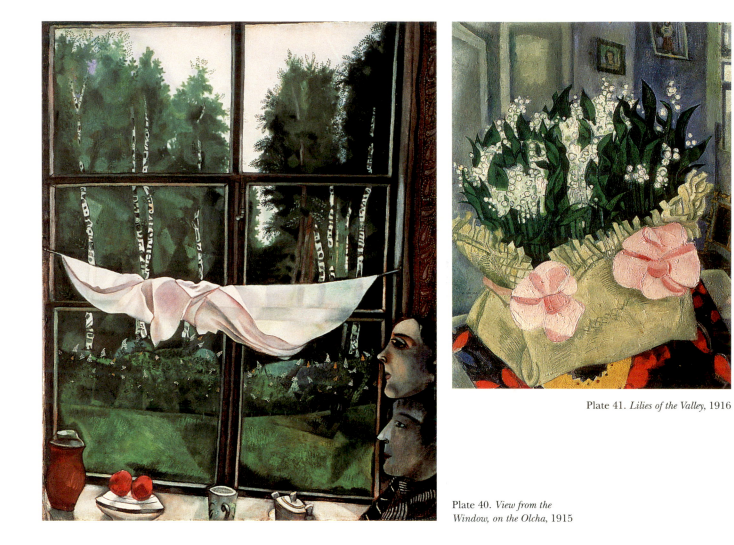

Plate 41. *Lilies of the Valley,* 1916

Plate 40. *View from the
Window, on the Olcha,* 1915

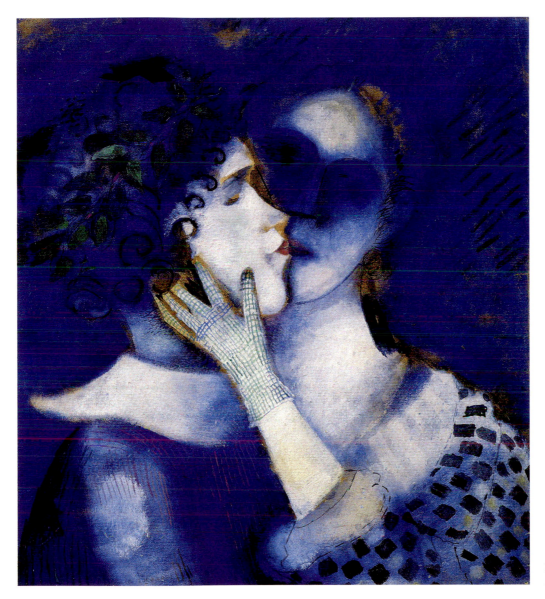

Plate 42.
Lovers in Blue, 1914

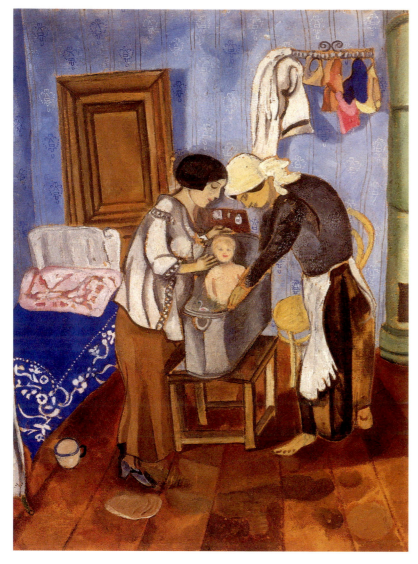

Plate 43. *The Infant's Bath*, 1916

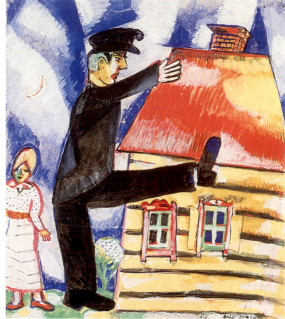

Plate 44. *In Step*, 1916

Fig. 9
Chagall, Bella and Ida, 1917. Ida Chagall Archives, Paris

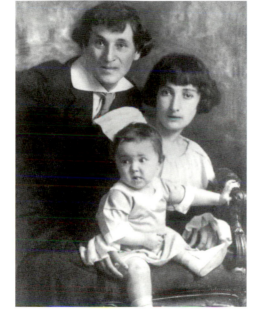

meet critics and poets who would be important to his achieving fame in later years. He was contributing to exhibitions and was increasingly recognized as a major figure of the Russian avant-garde. He received a major appreciation from Yakov Tugenhold in the prestigious journal *Apollon*, and the important collectors Ivan Morosov and Kagan-Shabshay began to seek out his work.[18] Chagall had a one-person exhibition at N. J. Dobychina's avant-garde Petrograd gallery in April 1916, where he showed sixty-three of his documents of Vitebsk. In November, some of his works were included at the Moscow exhibition of the artists' group Jack of Diamonds.[19]

The painted romance between Marc and Bella continued, and many of his compositions from 1915–16 express his private life. Following the birth of his daughter, Ida, Chagall painted a series of intimate domestic scenes that resonate with family bliss (Fig. 9). The doting mother in *The Infant's Bath* (Plate 43) assists as the barefoot housekeeper bathes the baby. *In Step* (Plate 44) is said to parody a command given by Bella to her husband.[20] The artist's figure dominates the composition as he good-naturedly executes her marching orders, an expression of his enthusiastic acceptance of her directives and the active role she played in their family.

WELCOMING A NEW ERA

Russia changed forever in 1917, when revolution toppled the tsarist regime and established a provisional government, followed six months later by the Bolshevik seizure of power. Like most of his coreligionists, Chagall welcomed the new era's promise, with its vision of a socialist utopia in which Jews would have full citizenship. An initial lifting of

landscape. The forest of silver birches behind the house in *View from the Window, on the Olcha* (Plate 40) is intersected by a curtain lifted to provide a clear view. The mask-like profiles of Marc and Bella are set one above the other, suggesting their emotional commitment. *Lilies of the Valley* (Plate 41) exudes a palpable joy as the flowers almost burst out of their basket and the room barely contains the arrangement.

That autumn, the couple moved to St. Petersburg, now renamed Petrograd. Chagall fulfilled his military service there with a job secured by his brother-in-law, Jacob Rosenfeld, in the press department of the office of wartime economy. It is extraordinary that during this tumultuous period, Chagall continued to paint and exhibit and to

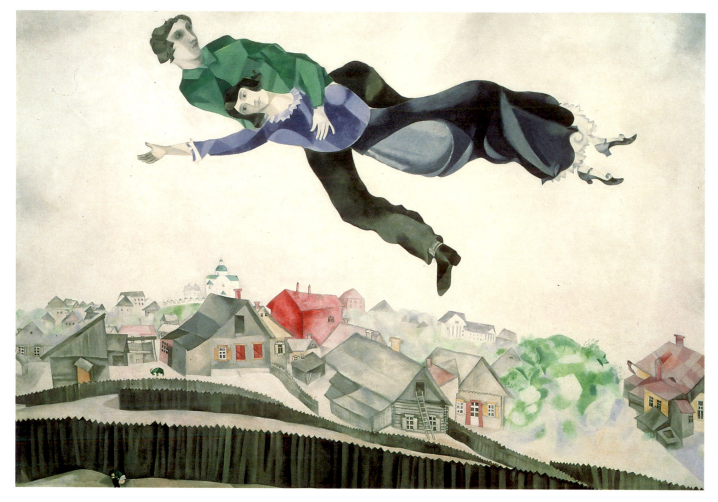

Plate 45. *Over the Town*, 1914–18

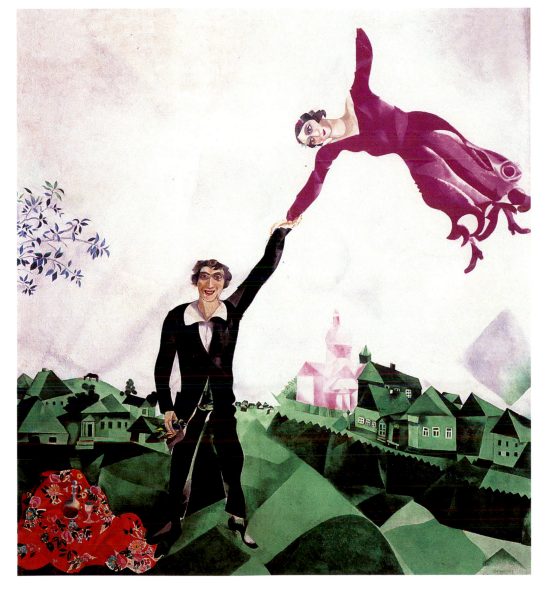

Plate 46. *The Promenade,*
1917–18

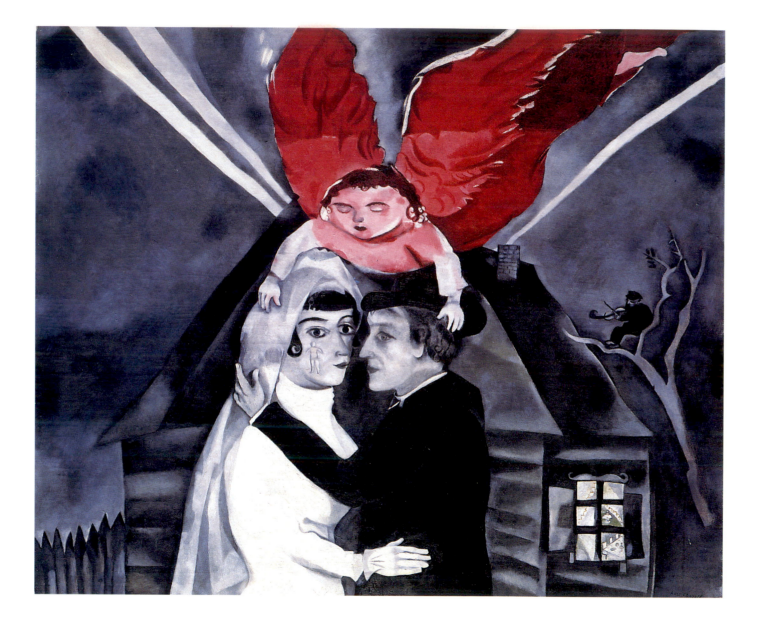

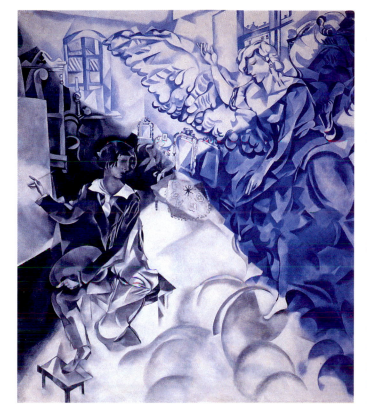

Plate 48. *The Apparition*, 1917–18

Opposite: Plate 47. *The Wedding*, 1918

restrictions served as a stimulus for an unprecedented Jewish cultural renaissance. Music, the plastic arts, and Yiddish literature, poetry, and theater flourished as Jews explored new avenues for expressing their national and cultural identities. Support for progressive movements in Russia propelled even those who were personally very private, like Chagall, into public activism. Anatoly Lunacharsky, People's Commisar for Cultural and Educational Policy, nominated him for the post of Director of Fine Art in the newly formed Ministry of Culture, along with Vladimir Mayakovsky and Vsevelod Meyerhold, who would head the Ministry's poetry and theater departments. However, Bella opposed Chagall's active engagement in politics, and they returned to Vitebsk where they lived in the large house of Bella's parents.

Once again, Chagall examined his town and its surroundings. He painted from nature while accompanying Yehuda Pen and his students on their outings to the countryside, where Pen kept the experience particularly enjoyable by screening Chagall from curious onlookers. Vitebsk figures prominently in two large-scale exuberant paintings executed between 1914 and 1918. A palpable love in *Over the Town* (Plate 45) lifts the artist and his wife to the sky above Vitebsk, yet the floating lovers, their bodies melded in union, remain anchored to the old city below, with its cathedral and wooden huts along the banks of the Dvina. In *The Promenade* (Plate 46), the artist grasps the weightless Bella by her hand as she flutters in the wind, binding her to the ground. In the other hand he holds a small bird, a reference to Maurice Maeterlinck's play *The Blue Bird*, an allegorical fantasy that portrays a hero and heroine who find true love not in their travels, but when they return to their simple home. The geometrical pattern of the grass

complements the transparent patterning of the sky. Three years after his marriage, Chagall painted *The Wedding* (Plate 47). This work makes iconographic references to a fifteenth-century French painting of Joachim and Anna, the apocryphal parents of the Virgin Mary, who in the original are shown embracing outside the Golden Gate.[21] Chagall has changed the earlier composition into a document of his own wedding: an angel above the heads of the couple foretells the birth of their baby (two years before the date of the painting), who has been drawn on the cheek of the bride. The fiddler and house symbolize their wedded state.

The Apparition (Plate 48) is one of Chagall's last major paintings in Vitebsk. According to the artist, it was connected to the memory of a dream he had during his difficult student years in St. Petersburg: "Suddenly, the ceiling opens and a winged creature descends with great commotion, filling the room with movement and clouds. A swish of wings fluttering, I think: an angel! I can't open my eyes; it's too bright, too luminous … . My picture *The Apparition* evokes that dream."[22] An alternative explanation might begin with *The Apparition*, a painting by El Greco that Chagall could have seen in Paris,[23] or a fifteenth-century Russian icon depicting the Annunciation to the Virgin.[24] Chagall replaces the figure of the Virgin Mary with a portrait of himself at the easel, implying that he has been inspired by God.

Chagall welcomed a commission to make small drawings to illustrate a Yiddish children's book,

"THE LITTLE KID"

Illustrations for *Mayselekh* by Der Nister (Pinchas Kaganovich)

Upper left: Plate 49. *Goat and Rooster*, 1916

Lower left: Plate 50. *Goat and Perambulator*, 1916

Upper right: Plate 51. *Child in Perambulator and Goat*, 1916

Lower right: Plate 52. *Goat in the Woods*, 1916

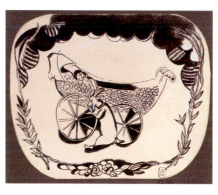

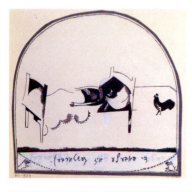

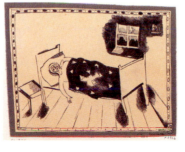

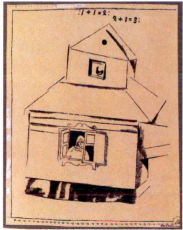

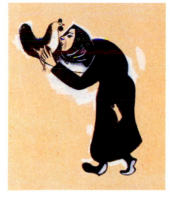

"STORY OF A ROOSTER"

Illustrations for *Mayselekh* by Der Nister
(Pinchas Kaganovich)

Upper left: Plate 53. *Grandma Is Dead*, 1916

Lower left: Plate 54. *The Little House*, 1916

Upper right: Plate 55. *Night*, 1916

Center right: Plate 56. *Rooster on Steps*, 1916

Lower right: Plate 57. *Woman and Rooster*, 1916

Tales in Verse, containing two poems, "A Story of a Rooster" and "The Little Kid," by Der Nister (Plates 49–57). This appellation, meaning "the hidden one," is actually a pseudonym for Pinchas Kaganovich. There is a strong link between Chagall's sharp graphic strokes in the tiny illustrations for Der Nister's stories and the plastic quality of the book's Hebrew letters. As a child, Chagall learned the Hebrew alphabet before the Cyrillic, and it appears to have had a strong influence on the graphic structure of his artwork.[25]

It is clear from his paintings of this period, as well as from drawings and illustrations for Der Nister's Yiddish tales, that Chagall was moving away from representations of reality, despite his renewed connection with Pen, the realist. Chagall turned toward his own blend of fantasy and modifications of the prevailing contemporary styles he had first experienced in

Fig. 10
Abram Efros and
Yakov Tugenhold,
Marc Chagall,
Moscow, 1918.
Collection Jacob
Baal-Teshuva,
New York

Fig. 11. *The School-Committee,* summer 1919.
Seated in the middle, Chagall; third from left,
Pen; on the right, Yermolayeva and Malevich.
Private Collection, Moscow

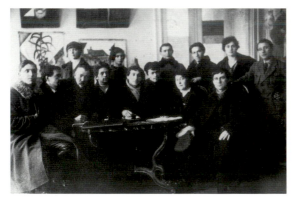

St. Petersburg and Paris. While Chagall had established a separation from the radical styles of Russian art, he was not indifferent to the concerns of the predominant avant-garde artists of his homeland. His participation in exhibitions of modern Jewish art called attention to the work of other young Jewish artists, such as Natan Altman, Robert Falk, and El Lissitzky, all of whom were aware of Jewish tradition but sought original artistic solutions that owed much to Cubism and Futurism.[26] He also took part in the 1917 "Exhibition of Jewish Artists" in Petrograd, and in the following year was included in Moscow's "Exhibition of Painting and Sculpture by Jewish Artists."

COMMISSAR OF ART FOR VITEBSK

Instead of continuing to live peacefully and create pictures, which was all he had ever aspired to do, Chagall decided in 1918 to turn his attention to administrative activities related to the new Bolshevik regime. The opportunity came after publication of the first illustrated monograph about Chagall's art, by the prominent art critics Yakov Tugenhold and Abram Efros (Fig. 10). The artist was then asked by the Soviet government to become Commissar of Fine Arts for the district of Vitebsk. This time, Bella assented, and Chagall decided to accept the position. It afforded him the authority to organize art schools, museums, lectures, and other artistic ventures within the city and region. From September 1918 until May 1920, when Chagall left Vitebsk for the last time and settled in Moscow, he concentrated his activities on his museum and school.

The notion now prevailed in cultural circles that constructing a new society demanded new forms, and the young regime equated revolution in politics with revolution in art. A sense of creative excitement enlivened the avant-garde artistic community as formalist experimentation was initially encouraged, based on the belief that it would enlighten and fulfill a popular function. Chagall's initial activity upon becoming Commissar was to decorate Vitebsk in order to

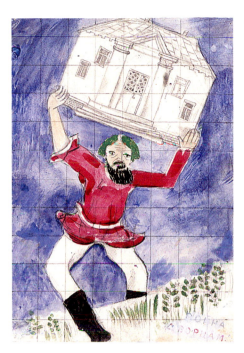

Plate 58.
*Peace to Huts –
War on Palaces,*
1918

in the cow's belly, etc. Anyway, let Marx, if he is so wise, come to life and explain it to you."[27] For the celebration, Chagall made the drawing *Peace to Huts – War on Palaces* (Plate 58) as a sketch for a street decoration.[28] The Goliath-like figure lifting a palace in order to destroy it encapsulates the new proletarian ideology and expresses Chagall's belief in the emerging new order.

Chagall founded a museum in Vitebsk for new art, but he directed most of his efforts to the Vitebsk Art Academy, opened in January 1919 in the house of a former banker. The school proved to be a difficult child to raise, owing to the complicated artistic politics it engendered (Fig. 11). Chagall had persuaded several important artists, including some of his own former instructors, to teach in Vitebsk. Mstislav Dobuzhinsky, Ivan Puni, his wife Xenia Boguslavskaya, and even Yehuda Pen accepted his invitation.

These faculty members caused no difficulties. However, in his optimism about the possibility of attracting the foremost Soviet artists, Chagall also invited Kazimir Malevich and El Lissitzky, in the misguided belief that artists practicing Suprematism and Constructivism – artistic theories that abandoned traditional representation – could work alongside academic artists such as Pen and Viktor Mekler. Malevich, with Lissitzky as an ally, soon polarized the student body. Furious power struggles arose between the school's director and Malevich, whose uncompromising ideas regarding abstraction and non-objective art left no room for the human dimension so crucial to Chagall's life and art. Suprematist ideology held that Chagall's faux-naïve style was outdated, and a faction of students and faculty conspired to force him to submit his resignation. Given Chagall's own words – "all I ever wanted to do was paint" – he may have been ready to leave anyway.[29]

commemorate the first anniversary of the new republic. Determined not to be outdone by Moscow and Petrograd, he created a vast outdoor spectacle that mobilized all of Vitebsk's artists and craftsmen and adorned the town with a profusion of decorative motifs designed to bring art to the people. The decoration and style, incorporating multi-colored animals and flying horses, caused bewilderment rather than pleasure, leading Chagall to comment, "Don't ask me why I painted blue or green and why a calf is visible

THE THEATER MURALS

Amid the furor of school politics and his subsequent departure from Vitebsk, Chagall continued his creative development, finding an outlet in the theater. He collaborated on nine theater productions in Vitebsk for Red Army soldiers, and was also commissioned to design sets for two plays by Gogol for Petrograd's Hermitage Studio.[30]

Chagall's most challenging and satisfying theater project was, not surprisingly, one that combined his artistic vision with his Jewish heritage. In November 1920, he accepted a commission from the State Jewish Chamber Theater in Moscow to design the set and costumes for its inaugural production, an evening of one-act plays by Sholem Aleichem, which opened on January 1, 1921. The Yiddish theater had existed for years in the margins of recognized cultural activities, but was now considered an official part of a large and increasingly well-organized Soviet cultural machine. Since the large majority of Russia's Jewish population still spoke Yiddish, it was obvious to the revolutionary leaders that Yiddish should be the means by which to convert the Jewish masses. Chagall enthusiastically accepted the opportunity to revolutionize the traditional Jewish theater. The artist "flung himself at the walls," as he would later write. "Ah! I thought, here is an opportunity to do away with the old Jewish theater, its psychological naturalism, its false beards. There on these walls I shall at least be able to do as I please and be free to show everything I consider indispensable to the rebirth of the national theater."[31]

Seeking to create a synthesis between the stage, where the actors were performing a text by Aleichem, and the walls that encompassed the stage, where the world of Aleichem would be brought to life, Chagall went far beyond traditional concepts and combined all aspects of the theater into an integrated whole. He needed little more than a month to complete the vast figurative scenery that would occupy the walls of the small theater, which seated ninety, as well as a ceiling painting and the stage curtain (Fig. 12) (both of which were lost when the theater moved to more spacious premises in 1924).

Chagall filled the murals with energetic, frenzied figures and dominant colors, to evoke the atmosphere of a Jewish Purim carnival with actors, acrobats, and Sholem Aleichem characters. The largest mural, *Introduction to the Jewish Theater* (Plate 59), measured nine by twenty-six feet and occupied most of one wall. Here broad bands of color travel across the enormous canvas, and geometric shapes of prismatic color rotate over the surface. Chagall combined representations of specific individuals with anonymous figures. He even included a portrayal of himself being presented by the theater director Abram Efros to the stage director Aleksei Granovsky. The important Yiddish actor Solomon Mikhoels appears in several different locations, dancing with unrestrained verve to lively music. A group of *klezmer* players, itinerant musicians popular at *shtetl* festivities, occupies the center, and to their right, acrobats seem suspended as they stand on their heads. Most of the images are contained within diagonal bands of color or segments of circles, an acknowledgment of the avant-garde artistic currents of the period.

The facing wall contained four vertical panels, each bearing a single image symbolizing the four arts. Chagall's muses are *Literature* (Plate 63), portrayed by a Torah scribe who sits bent over a scroll; *Theater* (Plate 62), represented by a *badchen*, a professional jester popular at Jewish weddings; *Dance* (Plate 61), in which a matchmaker at a

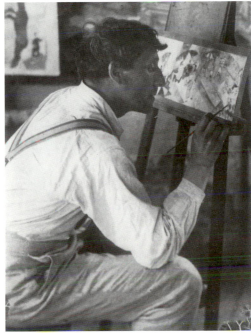

Fig. 12. Murals for the State Jewish Chamber Theater, Moscow

View toward stage

1 *Introduction to the Jewish Theater*
2 Between the windows:
 Music, Dance, Theater, Literature
3 Frieze: *The Wedding Feast*
4 Exit wall: *Love on the Stage*
5 Ceiling
6 Curtain

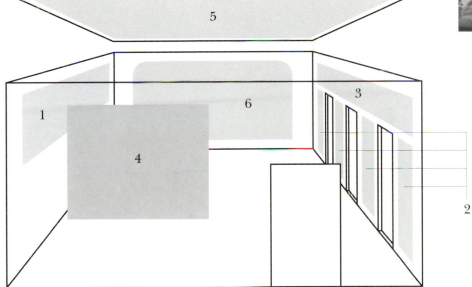

Fig. 13. *Chagall Painting "Study for 'Introduction to the Jewish Theater,'"* 1919–20. Collection Jacob Baal-Teshuva, New York

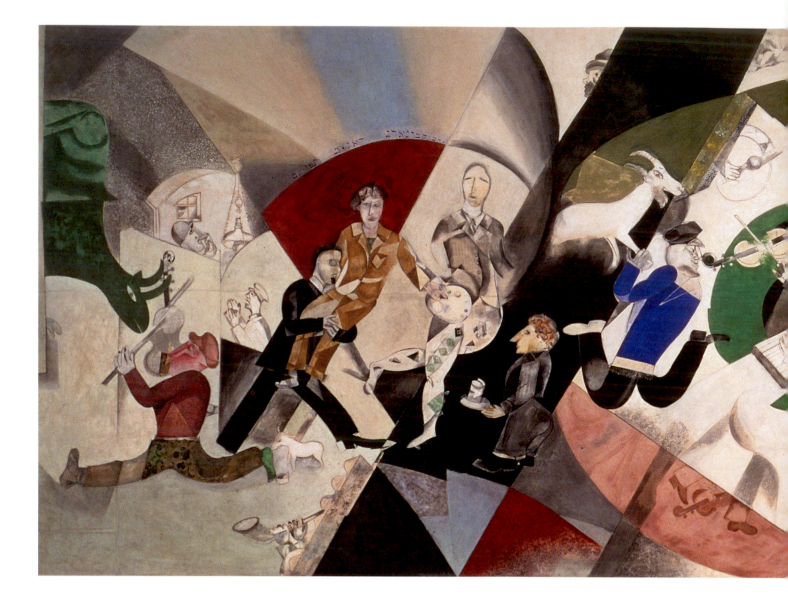

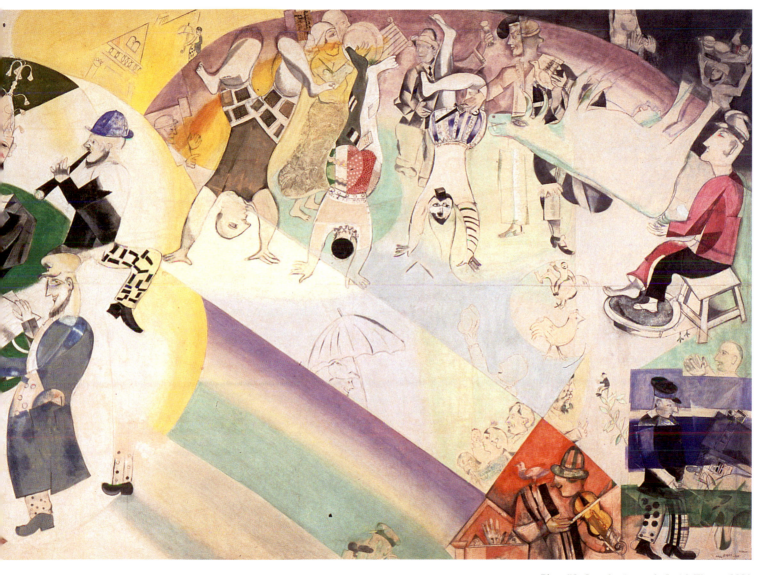

Plate 59. *Introduction to the Jewish Theater*, 1920

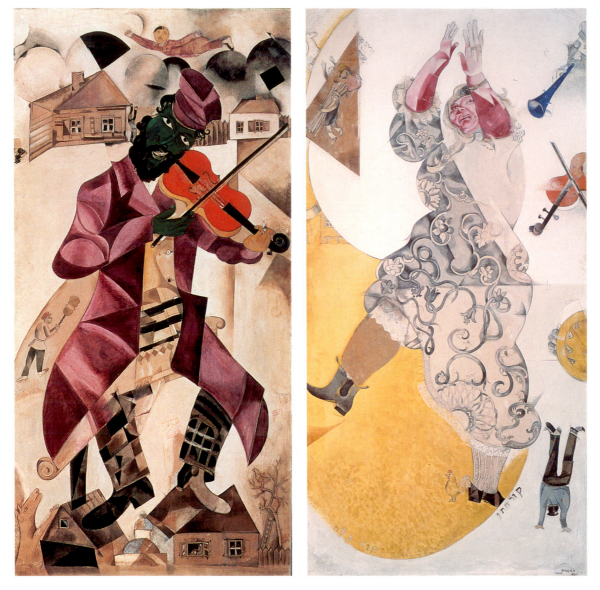

Plate 60. *Music,* 1920

Plate 61. *Dance,* 1920

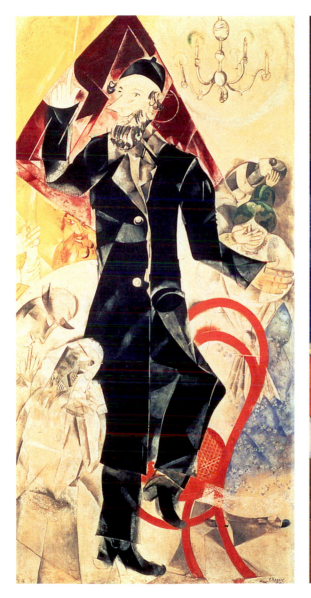

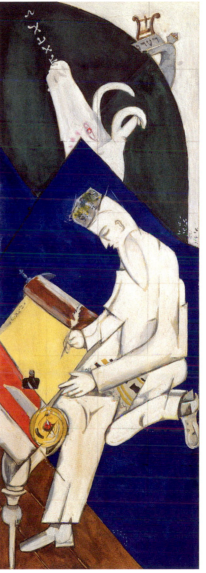

Plate 62. *Theater,* 1920

Plate 63. *Literature,* 1920

Plate 64. *Wedding Feast*, 1920

wedding claps her hands while dancing to a popular Jewish tune; and *Music* (Plate 60), which reuses a theme that Chagall explored repeatedly from 1908 – the violinist, a perennial player at Jewish weddings, particularly in villages where there were no orchestras.[32] The music muse plays his orange violin against a cubist sky, surrounded by elements of a Russian village, while in *Literature* Chagall's signature emanates from the mouth of the cow. Surmounting these four vertical paintings is *Wedding Feast* (Plate 64), a painted frieze depicting a Jewish marriage feast laid out on long tables.

The least representational of the works was a large square hung on the theater's exit wall, across from the stage. This depiction of two classical dancers, entitled *Love on the Stage* (Plate 65), is painted in various tones of gray and white, it almost fades into abstraction with splintered figures in a loose cubist style.

The exuberance of the theater murals belies the difficult times that lay ahead for artists and for Jews during the Stalin years. Following Lenin's death in 1924, Stalin unilaterally led the party and, between 1928 and 1932, subjected the arts to a gradual tightening of state control.

While Jewish artists and intellectuals fell victim to a wave of purges and deportations, the murals survived. They were even rehung in the foyer of a new building, where they remained on view until 1937. A decade later, in response to increasing criticism and physical danger, they were removed and hidden beneath the stage for safety. In 1948, Stalin's anti-Jewish campaign was signaled by the murder of Solomon Mikhoels, the final director of the State Jewish Chamber Theater, and in 1949 the theater was formally shut down. Chagall's work, along with that of many other Soviet artists, was branded "decadent" and not allowed to be exhibited until well after Stalin's death in 1953. Meanwhile, the murals were stealthily transferred by the Commission for the Liquidation of the Moscow Jewish Theater to the state-owned Tretyakov Gallery in the same city. They were not exhibited or even unrolled until 1973, when they were signed and dated by Chagall, who returned briefly to the Soviet Union after a self-imposed exile of fifty years (See Petrova, below, p.84, Fig. 1).[33]

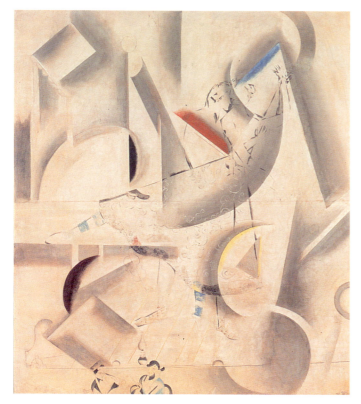

Plate 65. *Love on the Stage*, 1920

FINAL DAYS IN RUSSIA

Several years before Stalin's artistic purge started in 1928, Chagall and fellow Jewish artists had begun to chafe under increasingly restrictive state controls over the art world. The closing of private and commercial galleries and the nationalization of collections began to undercut the economic opportunities for independent artists, who soon concluded that they had no future in the Soviet Union. In the rapidly shrinking private market, Chagall could sell few of his works, and he was not even paid by the government for the murals at the Jewish theater. Chagall left, with travel funds from the collector Kagan-Shabshay, in 1922. It was the same year that "The Exhibition of the Three" (with Natan Altman and David Shterenberg) was on view. This was his last show in Russia and the last major exhibition of Jewish artists in Moscow.

Chagall departed from a Russia that had become a place very different from the world of his youth, and this new world was in many ways painful for him. The regime's move toward authoritarian government revived memories of tsarist autocracy, while the dislocation of traditional *shtetl* culture began separating Chagall from his personal and artistic roots. Would Russia continue to provide a place for art springing from Jewish tradition and experience? His teacher and mentor Yehuda Pen thought it might, and he stayed. For another fifteen years, until he was murdered in 1937, Pen worked in the idiom of the Jewish genre, producing a unique body of work that has survived and connects the pre- and post-Soviet worlds.[34] Ironically, both Pen within the country and Chagall outside of Soviet Russia were recreating a home that was already lost.

NOTES

1 Michael Stanislawski "The Jews and Russian Culture and Politics," in Susan T. Goodman, ed., *Russian Jewish Artists in a Century of Change, 1890–1990*, exh. cat. (New York: The Jewish Museum, 1996), p. 17.

2 Ibid., p. 20.

3 Marc Chagall, *My Life*, trans. Elisabeth Abbott (New York: Da Capo Press, 1994), p. 54.

4 Grigori Kasovsky in *Artists from Vitebsk: Yehuda Pen and His Pupils*, trans. L. Lezhneva (Moscow: Image, 1992), presents the life of Yehuda Pen in the context of the Vitebsk School of Art. The work contains more reproductions of work by Pen and related text than any other book in English.

5 Ibid., p. 29.

6 "Bletlach" (leaflet), *Strom* (1922), no. 1, p.45.

7 Kasovsky, *Artists from Vitebsk*, p. 46.

8 Grigori Kasovsky, "Chagall and the Jewish Art Programme," in Christoph Vitali, ed., *Marc Chagall: The Russian Years, 1906–1922*, exh. cat. (Frankfurt: Schirn Kunsthalle, 1991), p. 54.

9 Kasovsky, *Artists from Vitebsk*, p. 44.

10 Ibid., p. 44.

11 Ziva Amishai-Maisels, "Chagall and the Jewish Revival: Center or Periphery?" in Ruth Apter-Gabriel, ed., *Tradition and Revolution: The Jewish Renaissance in Russian Avant-Garde Art, 1912–1928*, exh. cat. (Jerusalem: The Israel Museum, 1987), p. 73.

12 Marc Chagall, Letter to Yehuda Pen, September 14, 1921, in Vitali, op. cit., p. 61.

13 Alexander Kamensky, "Chagall's Early Work in the Soviet Union," in Vitali, op. cit., p. 42.

14 Chagall, (1994), p. 119.

15 Susan Compton, *Chagall*, exh. cat. (London: Royal Academy of Arts, 1985), p. 183.

16 Ibid., p. 189.

17 See Ziva Amishai–Maisels, "Chagall's Jewish In-Jokes," *Journal of Jewish Art* 5 (1978), p. 92, for a discussion and transcription of the Hebrew texts.

18 Ya. Tugenhold, "I am Marc Chagall," *Apollon* 2 (1916), pp. 11–23.

19 Jacob Baal-Teshuva, *Marc Chagall: 1887–1985* (Cologne and New York: Taschen, 1998), p. 77.

20 Kamensky, op. cit., p. 48.

21 Susan Compton, *Chagall: Love and the Stage, 1914–1922*, exh. cat. (London: Merrell Holberton, 1998), p. 22.

22 Chagall, *My Life*, p. 82.

23 Compton,(1998) p. 22.

24 Mira Friedman, "Icon Painting and Russian Popular Art as Sources of Some Works by Chagall," *Journal of Jewish Art* 5 (1978), p. 100.

25 Franz Meyer, *Marc Chagall: Life and Work* (New York: Harry N. Abrams, Inc, 1963), p. 246.

26 John E. Bowlt. "From the Pale of Settlement to the Reconstruction of the World," in Apter-Gabriel, op. cit., p. 49.

27 Chagall, (1994), p.138.

28 Meyer, op. cit., p. 266.

29 Chagall, (1994), p. 173.

30 Compton, (1985), p. 198.

31 Chagall, (1994), p. 162.

32 Compton, (1985), p. 203.

33 Aleksandra Shatskikh, "Marc Chagall and the Theatre," in Compton, (1998), p. 32.

34 Pen was murdered for reasons that remain obscure to this day. For more on this, refer to Kasovsky's book, *Artists from Vitebsk*, p. 70.

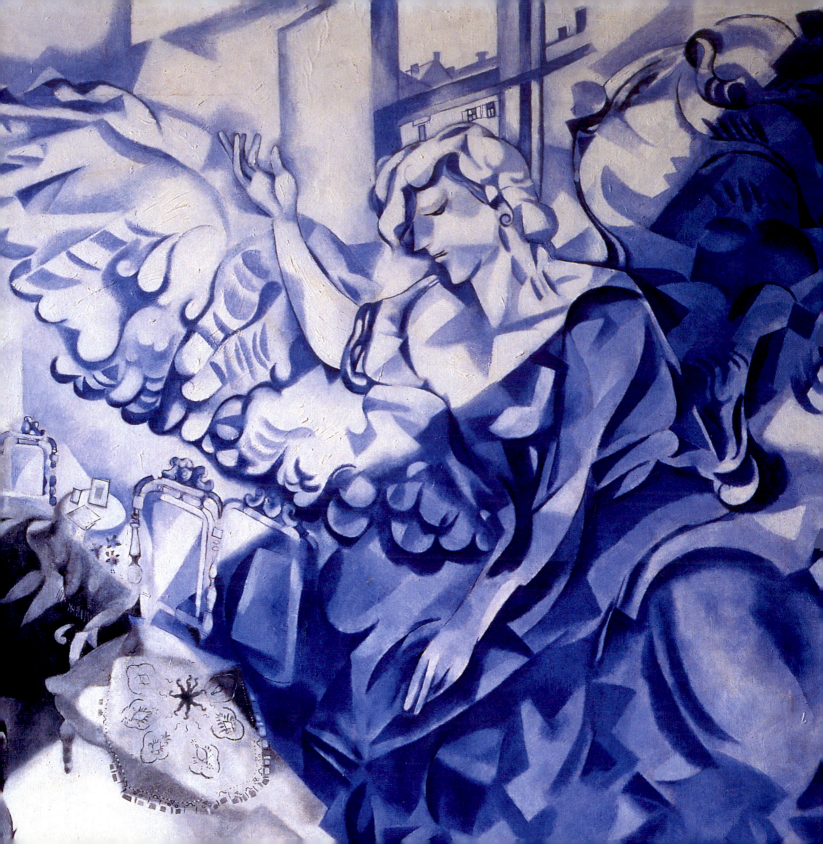

MARC CHAGALL
COMBINING THE INTIMATE AND THE COSMIC

Aleksandra Shatskikh

Most art critics agree that Chagall created his best works in Russia, during the most catastrophic period in its history. It was a country torn apart by world and civil wars, revolution, and the abyss of the post-revolutionary years formed the backdrop for Chagall's masterworks, the wall murals of the State Jewish Chamber Theater in Moscow. These "Jewish murals," as Chagall called them, have made a tremendous impression wherever they have been shown to the public. Their composition and subject matter provide material for new research, studies, and interpretations of the artistic heritage of this great twentieth-century artist.[1] Yet, the murals spent half a century languishing in oblivion.[2] For decades, Chagall struggled to show them in Europe and elsewhere, but to no avail. Not only did the Soviet regime reject the idea, but from the 1930s on the authorities did not even feel obliged to respond to inquiries from Chagall or his emissaries. From the 1940s through the 1960s, it was too dangerous to bring up this issue. Only in 1973, during his well-publicized visit to the Soviet Union, was the then elderly artist able to view the masterpieces he had produced in his youth. Sadly, he never actually saw them exhibited in Western Europe.

TEACHER AND PUPIL

The theater murals draw their unique character and significance from the artist's entire Russian experience. That experience was grounded in and defined by his relations with his first art teacher, Yehuda Pen (1854–1937), also known as Yudel' or Yuri Moiseevich Pen (Fig. 1). He instilled in his pupil a deep-seated understanding of his world vision, one that largely determined Chagall's artistic development.

The man who would become the patriarch of the Vitebsk artistic community arrived in the town in 1896, opening the Pen School of Drawing and Painting the following year (Fig. 2). It was here that little Moishe Chagall was brought one day by his mother. Pen taught the realistic artistic method that he had mastered in his own life drawings and paintings.

Opposite: Detail from Plate 48. *The Apparition*, 1913–14

Fig. 1. *At Pen's Studio:* Yehuda Pen (seated first from right), I. Maltsyn and F. Yakerson (standing left to right), and Yelena Kabischer-Yakerson (seated), mid-1920's. Private Collection, Moscow

Fig. 2. *Vitebsk, Gogolevskaya Street* (Yehuda Pen's studio and living quarters were in the white house on the left side). Private Collection, Moscow

Fig. 3. *Vitebsk with Bridge and Cathedral,* c. 1922
Private Collection, Moscow

Fig. 4. *Vitebsk, Smolenskaya Street,* c. 1920.
Private Collection, Moscow

Pen's originality derived from his unique iconography, which was deeply rooted in the world that surrounded him. At the turn of the century, all of the matchmakers, *magids,* sextons, rabbis, tailors, and shoemakers who served as his models were still alive. They had first and last names, lived in the houses that lined Vitebsk's streets, worked in their professions, and observed the Sabbath and all the Jewish holidays. Pen used his relatives, acquaintances, pupils, and friends as models for his paintings. The city streets, temples, and houses in Pen's paintings had a specific look of Vitebsk. Pen usually placed his images of ordinary life within a sacral setting – the patriarchal Jewish community and Jewish family, deeply permeated with daily rituals. His genre scenes – the family meal (*After Tsimes*),[3] reading a book together (*An Old Couple*), a venerable elder (*The Morning Reading of Talmud*) – seem straightforward at first glance but are filled with a palpable spirituality that reminds us of the town's strong Hasidic presence (Plate 5).

Pen's down-to-earth artistic vision was well attuned to this spiritual point of view. His reality was Vitebsk, where a variety of philosophies, lifestyles, and religions coexisted and interacted. Old postcards of Vitebsk show a city dominated by Russian Orthodox churches, as well as synagogues and Roman Catholic, Lutheran, and Old Believer churches (Figs. 3, 4). This nonconformist, multidimensional, and multifaceted borderland civilization was fully reflected in Pen's artistic vision. He chose the russified name and patronymic Yuri Moiseevich, by which his pupils addressed him, but he signed his paintings "Yu. M. Pen." Instinctively he had made a wise choice, feeding his creativity on the spirit of neighboring cultures rather than limiting it to traditional Jewish culture and thought.

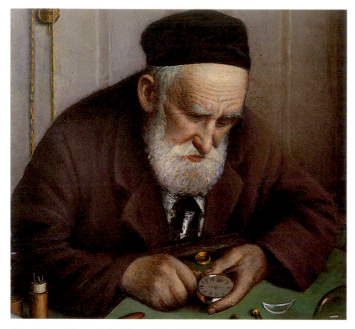

Detail from Plate 5. *The Clockmaker*, 1924.

emerged from Jewish and Slavic folklore, literature, and poetry. To this he added the artistic culture of Paris – Chagall's polyphonic art interwove color, expressivity, music, Jewish folklore, national symbols and traditions, and lessons learned from Russian icons and French Cubism.

Chagall cast a spell over the twentieth century, yet his mythology was firmly grounded in his native Vitebsk (Fig. 4), the same city that had shaped the artistic vision of his teacher (See Plate 12). Chagall inherited Pen's earthy philosophy as well as the main instrument for its transmission. The mentality that had given birth to Hasidism was transformed into a fertile source of creativity by both Vitebsk's art patriarch, whose work expresses an omnipresent love of life, and by its greatest pupil.

THE ARTIST ABROAD

In 1907, Chagall moved from provincial Vitebsk to St. Petersburg, the capital of the Russian empire, and from the studio of the modest provincial artist Pen to the studios of distinguished masters such as Nicholas Roerich, Mstislav Dobuzhinsky, and Leon Bakst. The latter were pillars of the World of Art movement, which played a key role in the development of Russian artistic culture. It was Bakst who introduced the young Chagall to the theater, through an invitation to execute the sets that Bakst had created for N. Cherepnin's ballet *Narcissus*, part of Diaghilev's celebrated *Russian Seasons*. The collaboration between the young provincial artist and the renowned master proved short-lived, but the World of Art view of the artist's primacy in the creation of a multi-media theatrical performance proved a direct influence on Chagall's later theater projects (Fig. 5).

Pen and Chagall had fundamental differences in their respective artistic visions, yet the pupil was indebted to his first art teacher for his understanding of art and the artist's mission. Pen, the nineteenth-century artist, "dressed" his inner vision in realistic form. Chagall, the twentieth-century artist, had a similar vision, but realized it with an extraordinary strength and unrestrained freedom that broke through the shell of naturalism and plausability. Chagall expressed himself through images that drew not just on the visible world, but on the phantasms of his subconscious and the stupendous verbal culture that

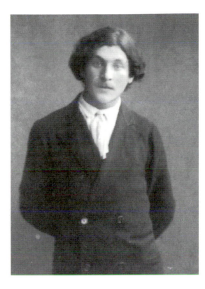

Fig. 5. *Marc Chagall*, 1908. Ida Chagall Archives, Paris

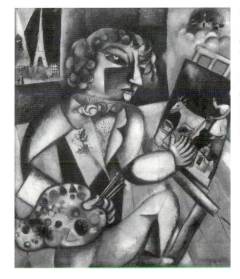

Fig. 6. Detail from *Self-Portrait with Seven Fingers*, 1913–14. Oil on canvas. 50⅜ × 42⅛ in. (128 × 107 cm). Stedelijk Museum, Amsterdam. © Artists Rights Society (ARS), New York/ADAGP, Paris

Upon his 1910 move to Paris, Moisei Chagall became the artist Marc Chagall. Until 1914, the emigrant from the Pale of Settlement immersed himself in great art, showing no preference for radical art movements or the established schools of art exhibited at the Louvre. Chagall considered Fauvism, Cubism, and Orphism as valuable as Rembrandt, Goya, and El Greco. He lived in a building called "La Ruche" (The Hive), at the epicenter of theoretical discussions regarding the future of Jewish art, but he refused to get involved in theoretical battles, which he viewed as lifeless scholasticism.[4] He had inherited Pen's belief in the natural development of artistic vision and was sensibly skeptical of the interest expressed by other Jewish artists in the creation of an exclusive national Jewish art.

The images of Chagall's faraway native land, which started to appear in his work, underwent a considerable transformation during this first Parisian period. Vitebsk began to take on the symbolic overtones of the Eternal City central to Jewish culture – the promised and lost Jerusalem. Chagall first depicted Vitebsk as the symbolic Temple City in his *Self-Portrait with Seven Fingers* (Fig. 6).[5] He modelled the temple on the Savior Transfiguration Church, which he could see from the windows of his parents' house on Pokrovsky Street. It was a real landscape, which Chagall would go on to paint many times. This combination of an intensely private vision of the real world and deeply rooted cultural archetypes led to the appearance of the symbolic, mythological images that became the hallmark of Chagall's art. The image of the cathedral with the green dome would reappear in his paintings throughout Chagall's life.

A DEVELOPING VISION

The twenty-seven-year-old artist who returned home in 1914 was still quite young, but he had already created immortal paintings. The actual Vitebsk overwhelmed Chagall, and images of its everyday life made a new and lasting impact on his vision. "The Russian Parisian,"[6] whom Guillaume Apollinaire considered "surnaturalist," untiringly painted the city's old men, his own relatives, landscapes, and scenes from life in Vitebsk. The subjects and themes of Chagall's works created during these years seem to openly follow those of his teacher, Pen (See Plate 27).[7] Chagall later named this cycle his "Vitebsk Documents." The more than seventy paintings and drawings in this cycle became the foundation for the strong structure and persuasive authenticity of Chagall's Vitebsk mythology, and served him well throughout the remaining seventy years of his life.

 It may be symbolic that at this time two portraits were created: one by the pupil, depicting his teacher, and the other by the teacher, of his pupil. Chagall's portrait of Pen is typical of his "Vitebsk Documents." He drew Pen's portrait in the teacher's studio (which also served as Pen's living quarters), where the walls were completely covered with paintings (See Fig. 1). After the Revolution, this work was purchased by the Vitebsk Museum of Contemporary Art.[8] According to rumor, it was exhibited in Pen's Memorial Apartment (which had become a local museum) until World War II, but the portrait is now presumed lost.[9] However, Pen's portrait of Chagall survives (See Plate 1). It shows the former pupil as a romantic and elegant young man in a wide-brimmed hat and white gloves, looking just as "the Russian Parisian" should in the

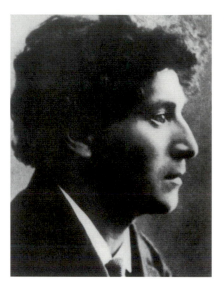

Fig. 7. Marc Chagall c. 1918. Ida Chagall Archives, Paris

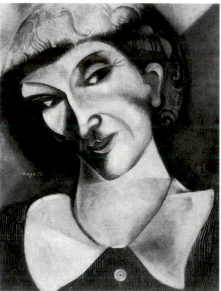

Fig. 8. Marc Chagall. *Self-Portrait*, 1914. Oil on cardboard mounted on canvas. 19⅞ x 15 in. Collection Im Obersteg, Switzerland. © Artists Rights Society (ARS), New York/ADAGP, Paris

eyes of the provincial *beau monde*. Pen exhibited the portrait at the same First State Exhibition of Moscow and Local Artists, held in Vitebsk in 1919. Incidentally, the exhibition was organized by Chagall in his capacity as Arts Commissar. Pen realized the significance of Chagall's activity for Vitebsk and used this occasion to donate the portrait to the city.[10]

Chagall's "Vitebsk Documents" express a powerful shift in artistic vision. His images became grandiose personal myths, despite the fact that they all had realistic, even genre sources (Plate 29). His "portraits" were of everyday objects (clocks, mirror, chandeliers, candles) or of actual landscapes (Vitebsk and the Dvina River) and buildings – the Assumption Cathedral, the Savior Transfiguration Church, the Town Hall, or Lyozno, where his grandparents lived (Fig. 4).

It was also during this period that Chagall created the greatest number of his self-portraits (Fig. 8). These reveal a struggle to establish his own identity, and also mark a decisive turn in his vision: henceforth, everything in his artistic universe was strictly autobiographical, seen through the prism of his personal life. Thus, in a dominant image, he transformed himself and Bella into a pair of lovers, and this emblem would run through his art for many years (Plate 66). Intuitively, Chagall sensed the tremendous artistic potential of combining the intimate and the cosmic. The young artist boldly revealed to the whole world his personal existence, permeated as it was with domestic bliss. No other artist had been as convincing as Chagall in creating images of a life infused with cosmic joy.

Chagall clearly understood the comprehensive, international character of his art, but that did not keep him from actively participating in the creation of contemporary Jewish culture. The Petrograd Jewish Society for the Promotion of the Arts, established in 1916, considered Chagall one of its most active members. Chagall and his family had moved to St. Petersburg the year before the organization was founded. In 1916–17, the artist created his first "new" images in sketches for the Public School at the St. Petersburg Main Synagogue. The commission for the school murals, by this Jewish art society, was Chagall's first of that kind. In his sketches Chagall openly glorified his family's private life. Two sketches on the same subject – *Visit to Grandparents* and *Baby Carriage Indoors* – depict Chagall's daughter, Ida, in a baby carriage, surrounded by playing nephews and nieces. They are set in the interior of a relative's house, a very familiar dwelling from Chagall's "Vitebsk Documents" (Plate 43). This autobiographical approach, unprecedented in its candor, would continue to dominate Chagall's other monumental works. While in Petrograd, Chagall executed his first independent work for the theater – the set and costume designs for N. Evreinov's *A Truly Merry Song*, staged in 1917 at the Comedians' Halt, an artistic cabaret. On the backdrop of the stage, Chagall painted an enlarged version of his 1911 painting *The Drunkard*. He had the actors paint their faces green and their hands blue, as part of an integral stage design that expressed his artistic vision.

COMMISSAR IN VITEBSK

Chagall returned from Petrograd to his native city in August 1918, armed with a mandate as Commissar of Arts for Vitebsk and Vitebsk Province. Abolition of the Pale of Settlement had given rise to new utopian hopes, but interestingly, Chagall's actions as a Soviet political figure were aimed at developing the pre-revolutionary activities

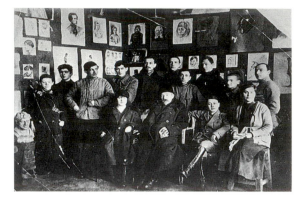

Fig. 9. *Yehuda Pen* (seated second from left) *with the students of the Vitebsk Popular Art School,* 1920. At the left, E. A. Kabitscher; third from left, Mikhail Kunin; second on the right, M. M. Lerman. Private Collection, Moscow

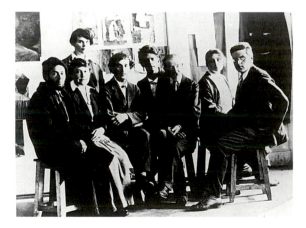

Fig. 10 *The School-Committee of the Vitebsk Art School in Fall 1919*, seated from left El Lissitzky, Vera Yermolayeva, Marc Chagall, a student, Yehuda Pen; on the right, Alexander Romm. Collection Jacob Baal-Teshuva, New York

begun by Pen. One of his most favored projects was the Museum of Contemporary Art, which pursued the educational mission of Chagall's first teacher. For decades, Pen had exhibited his own works and those of his pupils on his own walls, thus making his apartment Vitebsk's first *de facto* art gallery. Chagall's other significant accomplishment as Arts Commissar was to organize a professional art school, and here too he was following in Pen's steps (Figs. 9, 10).

Chagall performed his duties enthusiastically, but soon had to face facts. He learned the hard way, from his own experience, that the promises and assurances of the Soviet authorities were merely demagoguery. Nonetheless, this brief period of high expectations produced remarkable masterpieces, including the complex, monumental decorations that Chagall created in 1918 and 1919 for Vitebsk to celebrate the anniversary of the Revolution and other holidays.

Like many Russian artists of this period, Chagall executed murals, but his were dramatically different from all of the others. Chagall introduced purely autobiographical subjects and themes into monumental decorative works made to celebrate the dawn of a new age. In late 1918, to welcome the People's Commissar of Education, Anatoly Lunacharsky, on a visit to Vitebsk, Chagall created a huge mural that repeated the motif of his oil painting *The Promenade* (Plate 46).[11] The mural bore the slogan, "Welcome Lunacharsky." The visit was canceled, but the enormous mural, depicting Bella unfurled over Chagall's head like a flag, was duly installed on Vitebsk's main street. Contemporaries had their own, highly personal perceptions of Chagall's use of autobiographical motifs in public art. One female student at the Popular Art School later recalled that some local

ladies, brought up in puritanical households, avoided the street where this mural was installed because they were embarrassed by the sight of Bella flying with her legs in the air and her dress pulled up (Plate 46).

The Vitebsk festive murals were the precursors of Chagall's theater murals, both in their public destination and technique of their execution. Both were painted on canvas, for easy transportation and installation in different places. This long remained Chagall's medium of choice: his monumental ceiling decorations in the Paris Opera were also painted on canvas, a reflection of the master's revolutionary period. Chagall did a lot of work for the theater during his last years in Vitebsk, 1918–20. He regularly produced work for the Theater of Revolutionary Satire (Teresvat), which was developing the newly elevated traditions of cabaret, skit, and folklore. Later, when both Chagall and the Teresvat Theater moved to Moscow, there were plans for the artist to produce designs for D. Smolin's *Comrade Khlestakov,* a contemporary adaptation of Gogol's *The Inspector-General,* but this project fell through. Early in 1919, Petrograd's Hermitage Theater commissioned the artist to design sets and costumes for Gogol's plays *The Marriage* and *The Gamblers,* but neither play ever opened.

When Chagall left his native city in summer 1920, he had no idea he would never return. He departed deeply offended, because his pupils, to whom he had devoted so much effort, preferred the intractable avant-gardist Kazimir Malevich (See p. 58, Fig 11). In fact, Chagall had made several attempts to abandon his administrative duties, which he had grown to hate, even before Malevich arrived in Vitebsk. Nonetheless, for the rest of his life Chagall blamed the creator of *The Black Square* for his departure from Vitebsk.

TRIUMPH IN THE THEATER

Chagall's hour of triumph would come in hungry and cold Moscow. On November 20, 1920, he met the Director of the State Jewish Chamber Theater, Aleksei Granovsky, and on January 1, 1921, the renovated theater in Bolshoi Chernyshevsky Lane opened its season "under the sign of Chagall." The story of how the Jewish Theater's murals were created has been told both by Chagall, in his autobiography, *My Life,* and by the outstanding art historian and critic Abram Efros, who had the original idea to invite Chagall to work for the Jewish Theater.

When Efros recommended Chagall to Granovsky, he felt confident that the young man from Vitebsk, who so brilliantly combined the lessons of the European art tradition with a love for the everyday existence of his people, would be able to revive and re-energize the national theater. The artist far exceeded Efros's expectations. In actuality, it was entirely Chagall's idea to create the murals. According to Efros, the theater had planned that Chagall would do the artistic design for a play based on the writings of Sholem Aleichem. Chagall announced almost immediately, however, that along with the scenery he would paint "Jewish murals" on the large wall of the theater hall.[12] It soon became clear that these wall panels would be the touchstone for the theater's Jewish leitmotif. Chagall expressed an autobiographical perspective through themes derived from events in his own life. The combination of images produced by his poetic fantasies and depictions of real people gave *Introduction to the Jewish Theater* a double meaning as both the actual and a personal, metaphysical introduction. Despite visionary transformations of the images, Chagall painted convincing and recognizable

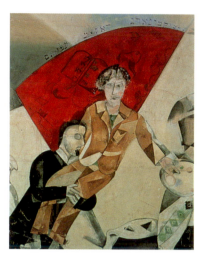

Detail from Plate 59. *Introduction to the Jewish Theater*, 1920

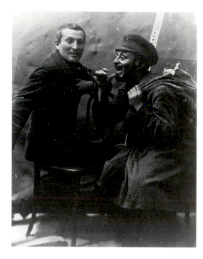

Fig. 11. *Chagall with the actor Solomon Mikhoels in a Chagall-designed costume for his role as Rabbi Alter for the Sholem Aleichem Evening*, January 1921. Collection Jacob Baal-Teshuva, New York

portraits of himself, Efros, Granovsky, Bella, his daughter Ida, Solomon Mikhoels (Fig. 11) the hunchbacked actor Chaim Krashinsky, musician Lev Pulver, and writer Isaiah Dobrushin. Chagall's depiction of his models as types did not make them any harder to identify.

The personalized motifs strengthen rather than diminish the universal effect of the murals. In *Introduction to the Jewish Theater*, the artist looks squarely into the viewer's eyes (the three other full-face figures – Granovsky, a musician in a hat with bells, and an acrobat standing on his head – do not look directly at the viewer).[13] Details that Chagall both realized in the performance and depicted in the mural also originated in Vitebsk. Thus, the green-faced violin player in *Music* had a real-life model: a sallow-skinned fiddler who played at the corner of Zamkovaya and Gogolevskaya streets in Chagall's hometown (Plate 60). The images of domestic animals, in addition to their

symbolic significance, were also reminders of daily provincial life.

Chagall could not squeeze portraits of every family member and relative into the murals, but his overwhelming love for them and his intense desire to depict them for eternity moved him to list their names in the murals. This is a significant point for understanding Chagall. We do not know the names of even the close family members of some other great artists of the twentieth century, but Chagall made sure that later generations would know the names of his parents, sisters, uncles, grandfather, and grandmother, because his universe could not exist without them.[14] The gates of the Jewish cemetery depicted in the mural remind us of a particularly sad event in Chagall's life: his mother, Feiga-Ita, died in 1916, when she was not yet fifty years old. Chagall was not in Vitebsk when she died or was buried, but as a memorial to his beloved mother, he painted

Cemetery Gates (1917) (Fig. 12).[15] The schematic image of the cemetery gates in the murals subtly introduces a mournful autobiographical note to the joyful universe of the theater carnival.

Chagall's murals, with their omnipresent autobiographical motifs, transform his relatives and acquaintances, familiar objects dear to his heart, and his native landscapes into integral components of the endless universe, while the earthy subjects of his paintings convey such universal notions as Love, Time, Space, Life, Death, Play, and Catastrophe. Chagall transforms strictly autobiographical motifs into formulas and myths about the crucial aspects of human life. Anyone can enter Chagall's artistic universe through real images from his life, and in this way experience a sublime unity and oneness with the artist and his aesthetic universe.

ALEKSANDRA SHATSKIKH
is Senior Fellow Researcher at the State
Institute of Art Studies, Moscow.

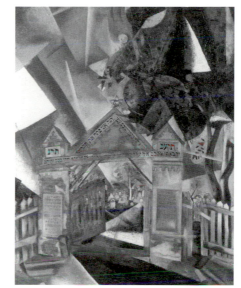

Fig. 12. *Cemetery Gates*, 1917. Oil on canvas. 34¼ x 26¹⁵⁄₁₆ in. (87 x 68.5 cm). Musée national d'art moderne, Centre Georges Pompidou, Paris. © Artists Rights Society (ARS), New York/ ADAGP, Paris

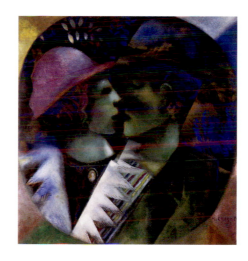

Plate 66. *Lovers in Green*, 1914–15

NOTES

[1] Even before the 1991 restoration, these murals drew the keen attention of researchers. See, for example, J. J. Sweeney, *Marc Chagall*, exh. cat. (New York: Museum of Modern Art, 1946); Matthew Frost, "Marc Chagall and the Jewish State Chamber Theater," *Russian History* 8, parts 1–2 (1981), pp. 90–107; Ziva Amishai-Maisels, "Chagall and the Jewish Revival, Center or Periphery?" in *Tradition and Revolution: The Jewish Renaissance in the Russian Avant-Garde Art, 1912–1928*, exh. cat., ed. Ruth Apter-Gabriel (Jerusalem: The Israel Museum, 1987), pp. 71–100; Avram Kampf, "Art and Stage Design," in Apter-Gabriel, op. cit., pp. 125–42.

The catalogue *Marc Chagall: The Russian Years, 1906–1922*, ed. Christoph Vitali (Frankfurt: Schirn Kunsthalle, 1991), has become the definitive reference on Chagall's Russian years. It contains articles and documents related to Chagall's theater work.

During the late 1970s, Professor Ziva Amishai-Maisels began writing articles about how Chagall used verbal means of expression in his art, elaborating on an observation made by early Chagall scholars. Guillaume Apollinaire, Blaise Cendrars, Yakov Tugenhold, Abram Efros, André Salmon, Franz Meyer, and others have also spoken and written about this. Amishai-Maisels has concentrated on the connection between Chagall's images and national verbal folklore; see "Chagall's Jewish In-Jokes" *Journal of Jewish Art*, 5 (1978), pp. 76–93; "Chagall's Murals for the State Jewish Chamber Theater," in Vitali, op. cit., pp. 107–27 (a revised version of this article with some new definitions was published in 1993: "Chagall's Murals for the State Jewish Chamber Theatre," in *Marc Chagall: Dreams and Drama: Early Russian Works and Murals for the Jewish Theatre*, exh. cat., ed. Ruth Apter-Gabriel [Jerusalem: The Israel Museum, 1993], pp. 21–39).

Professor Benjamin Harshav, who based his studies primarily on the theater murals, has demonstrated a new approach to the verbal component of Chagall's art, a component that is so material to Yiddish culture. See Harshav, "Chagall: Postmodernism and Fictional Worlds in Painting," in *Marc Chagall and the Jewish Theater*, exh. cat. (New York: Solomon R. Guggenheim Foundation, 1992), pp. 15–63; "Marc Chagall: peinture, theater, monde" [in Hebrew], *Apalayim* [Tel Aviv] 8 (1993), pp. 9–97; "The Role of Language in Modern Art: On Texts and Subtexts in Chagall's Paintings," *Modernism/Modernity* 1, 2 (1994), pp. 51–87.

Popular monographs of the late twentieth century pay considerable attention to Chagall's early Vitebsk years and his theater works.

See Alexander Kamensky, *Marc Chagall: The Russian Years, 1907–1922* (New York: Rizzoli, 1989); N. Apchinskaya, *Mark Chagall. Portrait of the Artist* (Moscow: Izobrazitel'noye Iskusstvo, 1995); M. Bohm-Duchen, *Chagall* (London: Phaidon, 1998). One of the latest works on Chagall's theater murals is Susan Compton, *Marc Chagall: Love and the Stage* (London: Royal Academy of Arts, 1998), pp. 13–25.

[2] Restoration of the three largest murals (*Introduction to the Jewish Theater*, *The Wedding Feast*, and *Love on the Stage*) started at the end of 1989 under the sponsorship of the Pierre Giannada Foundation, Martigny, Switzerland. A. P. Kovalyov, director of the restoration workshop at the Tretyakov Gallery, was in charge of the restoration. The complete ensemble of Chagall theater murals was shown for the first time since 1937 in the exhibition *Mark Chagall: The Russian Years, 1907–1922*, at the Pierre Giannada Foundation, Martigny, Switzerland, March 1–June 9, 1991.

[3] This Pen painting is now known as *Sabbath Meal* (Vitebsk Art Museum).

[4] Marc Chagall, *My Life* (Moscow: Ellis Lak, 1994), p. 101. On Chagall's independent position, see also J. Malinowski, *Grupa "Jung Idysz" i zydowskie srodowisko "Nowej sztuki" w Polsce. 1918–1923* (Warsaw: Polska Akademia Nauk, 1987), p. 87.

[5] Aleksandra Shatskikh, "Be Blessed, My Vitebsk: Jerusalem as a Prototype for Chagall's City," in *Poetry and Painting: Collected Works in Memory of N. I. Khardzhiev* (Moscow, 2000), pp. 260–68.

[6] The first article on Chagall's art was written by A. V. Lunacharsky and published in the Kiev newspaper *Kievskaya Mysl'* (no. 73, 1914), in a series entitled "Young Russia in Paris." The definition "Russian Parisian" was common for artists from the Russian Empire.

[7] Susan Compton's article underscores van Gogh's influence on Chagall's art in the 1910s. Before he went back to Russia, Chagall probably saw the van Gogh exhibit in May–June 1914 at the Paul Kassiner Gallery in Berlin (Compton, op. cit., pp. 16–17, 25). We know that Chagall had seen van Gogh's art earlier in Paris, so he was already an accomplished artist when he visited the van Gogh exhibition in Berlin. Before Chagall saw van Gogh's works for the first time, even his early works, such as *The Dead Man (Death)* of 1908 (Musée national d'art moderne, Paris), demonstrate an ecstatic expressiveness, while his iconic "Vitebsk Documents," despite their emotionally deformed images, most closely resembled the subjects and themes of his teacher Pen's works.

8 *The First State Exhibition of Moscow and Local Artists*, exh. cat., with an introduction by A. Romm (Vitebsk, 1919). The caption on page 13 reads, "M. Chagall, Portrait of the artist Yu. M. Pen (Vitebsk Museum)."

9 In a letter from pupil to teacher that was published in a Vitebsk newspaper but has escaped researchers' attention, Chagall asked Pen to send him a photograph of the portrait. Pen obviously granted this request because the photograph of Chagall's portrait of Pen survived; see Franz Meyer, *Marc Chagall: Life and Work* (New York: Harry N. Abrams, Inc., 1963), cat. no. 276.

10 Ibid.

11 *The Promenade* (1917–18) is in the State Russian Museum. The sketch for the mural, covered with squares drawn to make the enlargement, which Chagall gave to X. L. Boguslavskaya-Puni, is in the Israel Museum, Jerusalem.

12 Abram Efros, *Profiles* (Moscow, 1931), p. 201.

13 Benjamin Harshav has remarked on an inexplicable distortion of Granovsky's name, directly above his head. Actually, the explanation is simple and stems from everyday reality under Soviet rule. In 1928, when the Jewish Theater was touring Europe, Granovsky defected. It proved impossible to erase the name of the "traitor and defector" (the way the images of Stalin's purge victims were deleted from photographs) from the murals, which were meanwhile moved to the new building of the Jewish Theater on Malaya Bronnaya street, so his name was effectively deleted by distorting it beyond recognition. See Harshav's annotation to the painting *The Gates of the Jewish Cemetery*, in *Marc Chagall: Les années russes, 1907–1922*, exh. cat. (Paris: Musée d'art moderne de la ville de Paris, 1995), p. 201.

14 See Amishai-Maisels, "Chagall's Jewish In-Jokes," op. cit., pp. 80–81; and "Chagall's Murals for the State Jewish Chamber Theatre," op. cit., pp. 110, 118. Amishai-Maisels makes significant observations regarding the metaphorical and symbolic significance of "kosher" and "non-kosher" animals; however, she tends to be somewhat too literal when she ascribes to Chagall a conflict between Jewish and Christian values and asserts the negative implications of some images, which, according to her, allegorically depict the relations between Chagall, El Lissitzky, and Malevich. From his early youth Chagall had an extremely negative attitude toward the limited nationalistic reception of his art. Demanding that the Jewish Theater's board of directors organize an exhibition of his murals, he wrote: "I love Jews very much (the proof is ample), but I also love Russians and some other national minorities, and I am accustomed to painting serious works for many 'nationalities'" (Chagall to the Board of Directors of the State Jewish Chamber Theater, February 21, 1921; Manuscript Department, Bakrushin State Theater Museum, f. 584, op. 99, l. 57. Published in Vitali, op. cit., pp. 86–87. Harshav disagrees with Amishai-Maisels; see Harshav, "The Role of Language in Modern Art," op. cit., pp. 86–87.

15 Amishai-Maisels, "Chagall's Murals for the State Jewish Chamber Theatre," op. cit., p. 115; and Harshav, "Chagall: Postmodernism and Fictional Worlds in Painting," op. cit., p. 34.

CHAGALL IN RUSSIA
AFTER 1922

Evgenia Petrova

In the spring of 1922, Marc Chagall and his family departed Moscow for good, traveling via Kaunas, Lithuania, to Berlin. Chagall left behind bitter memories of his last few years in Russia, which he had spent painting murals and designing costumes for the State Jewish Chamber Theater in Moscow. That project had required him to travel almost daily from the nearby village of Malakhovka, where he lived with his wife, Bella, and their small daughter, Ida. Chagall described this experience in *My Life*: "To get there, I had to wait for several hours first in one line – to buy train tickets, then in another line – to be admitted to the railway platform."[1] A huge crowd full of pickpockets would be pushing in every direction, the train cars reeked of stale tobacco, and the passengers sang plaintively all the way to Malakhovka and back. The hunger, cold, and deprivations of wartime, the dirt and incivility, had been a trial.

Chagall's work at the theater came to an end. Kazimir Malevich, with whom Chagall had been on difficult terms ever since they had been colleagues in Vitebsk, was

becoming more and more influential in the New Art. Seeing no future for himself in Soviet Russia, and with the help of Anatoly Lunacharsky, the People's Commissar of Education, Chagall obtained permission to leave the country. Chagall's departure, like those of many others, was not conceived as a permanent break with the motherland.

By the time he left, Chagall was already a famous artist, and he continued to be referred to as a "Russian" master. Several books and articles had already been published about him.[2] In 1923, when Chagall was living in Berlin, the sculptor Boris Aronson wrote a slim book about him that was published by Petropolis.[3] In 1925, a unique exposition, *New Directions*, opened at the Russian Museum in Leningrad, with Chagall's *The Promenade* as its centerpiece (Fig. 2).

However, in 1926 the Soviet authorities shut down the Museum of Artistic Culture, which had been created with the initiative and direct participation of Russian avant-garde artists such as Malevich, Pavel Mansurov, Vladimir Tatlin, and Mikhail Matyushin. The museum had set itself the goal of housing works representing all the newest systems of Russian art. During its brief existence, the

Opposite: Fig. 1. Marc Chagall signing *Introduction to the Jewish Theater* at the State Tretyakov Gallery, 1973. Ida Chagall Archives, Paris

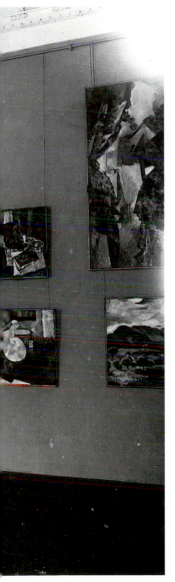

Fig. 2. From the exhibition
New Directions, at The State Russian
Museum, Leningrad, 1925.
The State Russian Museum,
St. Petersburg

museum had been very active exhibiting its collection and did much to shape a new generation of artists. Chagall was represented by several works: *The Mirror, Jew in Red, Father's Portrait, A Small Store in Vitebsk*, two drawings, and *The Wedding Ceremony*. (These works are now in the The State Russian Museum in St. Petersburg, except for the last, which is in the Tretyakov Gallery in Moscow.)

Before 1930, no one who wrote about Chagall or exhibited his works in museums and exhibitions ever separated him from Russia. Abram Efros wrote a remarkable collection of essays entitled *Profiles*,[4] published in Moscow in 1930, that provided biographical sketches of fourteen outstanding Russian artists. The vivid and sophisticated essay about Chagall, dated 1918–26, depicted the artist more accurately than anyone has since. Describing him as a Jewish artist from Russia, Efros linked Chagall's fairy-tale vision of the world and unique rendering of daily life to Hasidic culture, and the artist's cosmic outlook to his personal world view.

In Soviet Russia after the early 1930s, a silence fell over Chagall that lasted almost thirty years, not because he was singled out but because Stalin's totalitarian regime virtually prohibited the mere mentioning of artists of the Russian avant-garde (Fig. 3). Their works were removed from exhibition in major museums. An order issued by the Ministry of Culture caused many works to be moved from arts institutions in Moscow and Leningrad to distant provincial museums (See Plate 19). The silence continued even after Stalin's death in 1953. Like the political prisoners who were released from labor camps in the mid-1950s, avant-garde paintings slowly and cautiously re-emerged as connections that had been lost during the Iron Curtain years were reestablished.

Starting in the late 1950s, Chagall, like many others, renewed his correspondence with relatives, museum directors, and prominent cultural figures in the Soviet Union. At first Chagall cautiously sent letters with people who made trips abroad. For quite a while the well-known writer Ilya Ehrenburg served as the Chagall family postman.

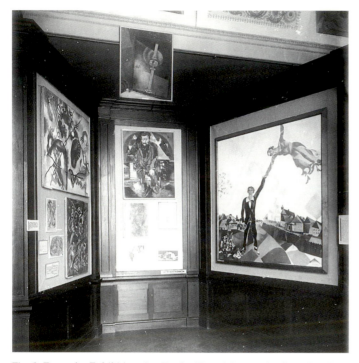

Fig. 3. From the Exhibition *Art, Epoch of Imperialism*, at the State Russian Museum, Leningrad, 1932.
The State Russian Museum, St. Petersburg

During the 1960s, when Chagall was again able to use the regular mail, he began asking about the fate of those works he had left in the Soviet Union.[5] Often he had no idea about the possible whereabouts of a specific object. The help of friends enabled Chagall to track down a few pieces. He also wrote to his friends about certain details of works he had left in Russia. Several letters that Chagall wrote during the 1950s and 1970s (See below pp. 92–95)

refer to what are now well-known paintings and drawings. Clearly, Chagall was upset over the regulations that prevented him from borrowing these works for major exhibitions abroad. He could not understand "what I am so guilty of, since my art and I have always been devoted to the spirit of homeland." As the letters also show, Chagall was gratified to learn that Russian art lovers remembered him.

Cultural life in the Soviet Union gradually returned to normal, and the bans were slowly lifted. During the mid-1960s, Moscow and Leningrad museums held exhibitions of art by previously banned artists, such as Kuz'ma Petrov-Vodkin and Zinaida Serebryakova, and also included works by Ilya Mashkov, Petr Konchalovsky, and Aristarkh Lentulov. Their art had been labeled "formalist" and been purged from the history of Russian art by the ideological watchdogs of Social Realism.

Chagall's name was virtually never mentioned in Soviet newspapers or magazines before the mid-1960s (a fate shared by many of his contemporaries, such as Malevich, Kandinsky, and Filonov). But in 1967, a collection of Lunacharsky's essays was published that included "Young Russia in Paris," which discussed Chagall.[6] The book represented a voice from the distant past, which turned out to have contemporary significance, for although Lunacharsky was talking about Chagall in the period around 1910, the Soviet intelligentsia suddenly learned that Chagall was alive and that Alexander Benois had seen his works at a Paris exhibition in 1940.[7] Soon afterwards, Ilya Ehrenburg wrote about his meetings with Chagall for a popular art magazine, *Decorative Arts*.[8]

After the Iron Curtain fell, Chagall at long last could be discussed publicly, but his return to a wider audience was slow. For example, the Russian Museum in Leningrad was

not permitted to hang *The Promenade* (See Plate 46) until 1973, when Chagall himself came to the city. The visit of the famous "French" artist was widely discussed in the media. People learned that the legendary Chagall came from Vitebsk and that he loved his native city and Russia. Television screens showed a happy Chagall strolling through the Tretyakov Gallery and the Russian Museum, delighted to meet his relatives in person.

Only a very few people knew what was going on behind the scenes of Chagall's visit. One of the artist's nieces told me that only Chagall's sisters and their children (his nephews and nieces) were allowed to join the family reunion. Where the reunion was to be held was the subject of numerous discussions. Finally, they settled on the Leningrad apartment of Chagall's sister Lisa – the very apartment he bought for her shortly before his visit to the Soviet Union. Chagall's niece told me that the presence of KGB observers gave the family reunion a rather strained air. On several later occasions he met privately with his sisters.[9]

For all of its difficulties, Chagall's visit to Russia in 1973 was a watershed (Fig. 1). His works that remained in Russia got a new lease on life because now they could be sent abroad for exhibitions and shown inside Russia itself. Articles about Chagall started to appear in the press.[10] In 1987, the Pushkin Museum of Fine Arts in Moscow organized the first major Chagall exhibition to commemorate the centenary of his birth.[11] The exposition included works from the private collection of Chagall's wife and daughter as well as works from other museums and private collections. In front of the museum there was always a long line of people who waited for hours to see the exhibition. The next year, in 1988, the Hermitage mounted a show of Chagall's graphics.

An avalanche of publications in newspapers and magazines followed,[12] as well as an album, *The Return of the Master,*[13] Alexander Kamensky's book on Chagall,[14] and numerous mass market editions. Art lovers were learning more and more about Chagall. Now no one was surprised to hear that he was a Russian Jew from Vitebsk, who studied art first in St. Petersburg and then in Paris. Many art lovers had already heard that he had enthusiastically accepted the Revolution and had been sent to Vitebsk to organize artistic life there. But the encyclopedia that was the principal reference for several generations still had an entry for Chagall that read: "Chagall, Marc Zakharovich (born July 6, 1887 in Lyozno near Vitebsk), French painter and graphic artist."[15]

The situation has not changed greatly. More recent biographical dictionaries state that Chagall was from Russia, but they still call him "a painter and graphic artist of the French school,"[16] which is, of course, very far from the reality of the situation. Chagall took his first art lessons in his native Vitebsk from the artist Yehuda Pen, after which he studied in St. Petersburg, and only after that did he go to Paris to finish his training, as was the custom among artists in those days. But he did not initially stay long in Paris.

Museums have been doing their best to correct the inaccuracies offered by the reference books. In 1991, an exhibition of Chagall's Russian period traveled from Frankfurt am Main to Moscow and Leningrad. For the first time, Russian viewers saw the enormous murals Chagall had painted for the State Jewish Chamber Theater, as well as other works created in Russia that had been preserved in Russian art collections. Chagall, who painted red and green cows, flying people, and violin players sitting on

roofs, was embraced by many art lovers as an artist they felt close to and could understand. The public came to love him.

The peak of Chagall's popularity in his native land coincided with a wave of interest in his early art outside of Russia. Chagall's works traveled so much during the early 1990s that they were seldom on display in The Tretyakov Gallery or the State Russian Museum. His Russian works have now been exhibited in Germany, Switzerland, France, Italy, Finland, and Austria. However, this is the first Chagall exhibition in the United States to include work exclusively from Russian collections, even though the artist once lived here and for many years had a strong connection to this country.

EVGENIA PETROVA
is Vice Director at the State Russian Museum, St. Petersburg.

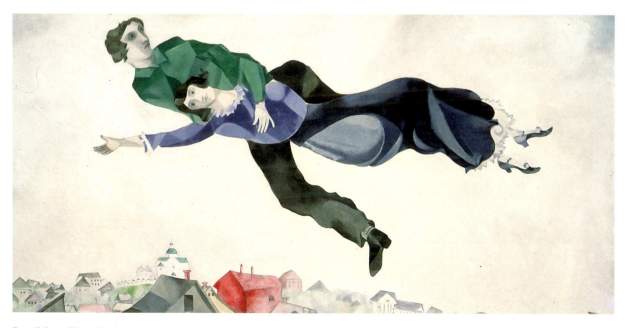

Detail from Plate 45. *Over the Town*, 1914–18

NOTES

1 Marc Chagall, *My Life* (Moscow: Ellis Lak, 1994), p. 166.

2 Ya. Tugenhold, "I am Mark Chagall," *Apollon* 2 (1916), pp. 11–20; Abram Efros and Ya. Tugenhold, *Mark Chagall's Art* (Moscow, 1918).

3 B. Aronson, *Mark Chagall* (Berlin: Petropolis, 1923).

4 Abram Efros, *Profiles* (Moscow, 1930).

5 Judging from exhibition catalogues and Marc Chagall's recollections, Chagall probably produced several hundred works before he left Russia in 1922. Not all of the works known from reproductions in old newspapers, books on Chagall, and exhibition catalogues have yet been located.

6 A. V. Lunacharsky, *On Visual Art* (Moscow, 1967).

7 Alexander Benois, *Alexander Benois Reflects* (Moscow, 1968).

8 I. Ehrenburg, "On Mark Chagall," *Decorative Arts*, 12 (1967).

9 For more information on Chagall's sisters, who lived and died in Leningrad, see Evgenia N. Petrova, "Chagall and his Relatives in Russia," in *The State Russian Museum: Pages from the History of National Art from the Late Fourteenth to the Twentieth Century*, vol. 6 (St. Petersburg, 1999), pp. 53-64.

10 Chagall's interview for the newspaper *Literaturnaya Gazeta* was given on October 16, 1985, and published the same year.

11 *Marc Chagall: For his Centennial. Paintings and Graphics from French and Russian Museums and Private Collections* (Moscow, 1987).

12 More than twenty newspaper and magazine articles were published in 1987 alone, including articles dedicated to Vitebsk written by Chagall in 1944 ("To My Native Vitebsk," *Literaturnaya Gazeta*, June 24 and September 7, 1987), Louis Aragon's cycle of poems dedicated to Chagall, Chagall's interviews for various newspapers, and articles containing information on the artist's life and work.

13 *Chagall: The Return of the Master: Moscow Exhibition, Centennial of the Artist* (Moscow, 1988). Authors of this volume included the poet Andrey Voznesensky; Maya Bessonova, a researcher at the Pushkin Museum of Art; and Dmitry Sarabyanov, a well-known art historian. The book also includes a chronology of his life and work, a catalogue, illustrations, and an introduction by Irina Antonova, Director of the Pushkin Museum of Art.

14 Alexander Kamensky, *Chagall: The Russian Years, 1907–1922* (New York: Rizzoli, 1989).

15 *Great Soviet Encyclopedia*, 3rd ed., vol. 29 (Moscow, 1978), p. 271.

16 *Concise Encyclopedic Dictionary*, vol. M–Ya (Moscow, 2000), p. 600.

FROM CHAGALL'S CORRESPONDENCE

The Chagall letters offered here mention works included in the exhibition at The Jewish Museum. Dating from the late 1950s through the 1970s, when citizens of the Soviet Union could again communicate with the West, the letters express Chagall's love and respect for Russia, as well as his correspondents' admiration for the artist and his work, their desire to help the artist locate his works, and their efforts to exhibit his works and make people aware of their existence.

The letters tell a captivating story about the complicated life of Chagall's paintings and drawings, which changed hands often and make valuable comments regarding some of the works that were found in Russia. They supply dates and significant details about the subjects of specific pieces. More importantly, they open a window to the emotions Chagall felt when locating a work, similar to those of someone who has found children thought forever lost.

Evgenia Petrova has edited the letters and supplied the commentary that follows.

I. M. G. Gordeyev[1] to M. Z. Chagall (1958)

Dear Marc Zakharovich,

Lilya Yurievna Brik[2] and Vasily Abgarovich Katanyan[3] have asked me to send you photographs of four of your works that I have in my collection. I gladly comply with this request. I am sending you:

1. *The Vision.* This painting is reproduced in *Zharptitsa* (Firebird) magazine, no. 11. At one time it was bought by Shimanovsky[4] (from Dobychina,[5] I believe). I purchased it from Shimanovsky's widow.
2. *The View from the Window. After Rain.* This is either Vitebsk or Lyozno. It used to be in Rybakov's[6] collection.
3. *Soldier with Small Loaves of Bread.*
4. *Jewish Wedding.*

The dimensions of the works are indicated on the back of the photographs.

Several of your works are in G.D. Costakis's[7] collection. There are several of your works in Leningrad.

If necessary, and if you wish, it would be possible to obtain their photos.

If we are talking about publishing a complete list of your works,[8] every find is important to you.

Let me take this opportunity to congratulate you on your recent seventieth birthday and, I believe, the fiftieth anniversary of your artistic career.

With all my heart and soul I wish you good health and success.

No matter where you live and work, we consider you our Russian artist.

This is not just my personal point of view.

You will find your name and a list of your works in the Tretyakov Gallery on page 464 of the *Catalogue of the State Tretyakov Gallery (Paintings of the XVIII–XX centuries)*, published in 1952.

I am eagerly awaiting the publication of your monographs on your art.

Respectfully,

M. Gordeyev

My address: Moscow,[9] 25 Kropotkinsky Lane, Apt.23
Phone G668–4

March 28th, 1958

II. M. Z. Chagall to M. G. Gordeyev (May 7, 1958)

Dear Mikhail Grigorievich,

I was so surprised and delighted to receive through Kremel[1] your photos of my old paintings – my entire life. I was particularly astounded to finally be able to see this *Vision*, which I think comes from 1916–1917.

The artist Brodsky[2] had this painting first, and after that I lost sight of it. At long last it had been found, and 2) *The View from the Window*. This is the window in my "room" in Vitebsk[3] with a bunch of flowers brought by my Bella; I think this was in 1908, and 3) *Soldier with small loaves of Bread* (1914). *Jew[ish] Wedding* surprised me – I would like so much to *examine* its technique with my own eyes.

But I must thank you for your attention and love for my art. I used to think that very few people remembered me and knew me in my homeland, but my homeland is always in my paintings. I dream, if it were possible, of borrowing your (my) works for the major exhibitions in Germany and Paris museums being organized now!

The same goes for several works from Moscow and Leningrad Museums. I am glad that you wrote to me. Keep in contact with me. I am so happy and grateful, and if you see paintings of mine anywhere that I don't know about – I would be pleased to receive their photos. This would also be needed for the large book about me that is being put together in Germany, France, and America.

Your devoted and grateful

Marc Chagall

III. M. Z. Chagall to M. G Gordeyev (1958)

Dear Mik[hail] Grigorievich,

I am writing to you again for I feel that you cherish kindly feelings for me. I hope that you have returned home well rested. As you know, in February, that is, today, my exhibition opens in Hamburg, in the municipal museum. Despite inquiries from the officials in Paris and German museums, so far there has been no response to their request to borrow my paintings that are in the Tretyakov Gallery and in Leningrad. I would like to hope for a positive response at least as regards the exhibition in Paris at the Art Decoratif Museum (Pavilon Marsan). Costakis,[1] a private collector from Moscow, personally delivered the works that belong to him for the exhibition in Hamburg; if he received permission, I think you might also be able to send the works that belong to you, particularly *Vision* and *Window in Vitebsk*. And if they arrive early enough, they could be reproduced in the catalogue, since all the paintings are being reproduced in the catalogue; if it is possible – please write me first – I will inform the curator of the museum who is organizing the exhibition, François Mathey. The exhibition in Paris will take place in early June. It will travel thereafter to Hamburg and Munich, where it will be in April. If you can send them to Munich, that would also be very good.

I apologize for writing this. I would be pleased if you would drop me a line. Of course, I am sad that [my works] were not sent from my homeland for my exhibitions (these exhibitions are unlikely to be repeated in this form in my lifetime). I do not know what I am guilty of, since my art and I have always been devoted to the spirit of my homeland.

Stay healthy. With cordial regards, Yours,

Marc Chagall

NOTES

Endnotes to Letter I

This letter is held in the archive of Mikhail Yablochnikov (St. Petersburg). First publication.

1. Mikhail Grigorievich Gordeyev (1905–1967), artist, journalist, collector. Lived in St. Petersburg until 1944, then in Moscow.

2. Lilya Yurievna Brik (1891–1978), actress, close friend of the poet Vladimir Mayakovsky. Author of *Reminiscences* (Moscow, 1963), which largely concentrated on Mayakovsky.

3. Vasily Abgarovich Katanyan (1902–1980), literary scholar, author of *Mayakovsky: Chronicle of His Life and Work*, 5th ed. (Moscow, 1986), republished several times. In the 1950s, he was married to Lilya Brik.

4. Anton Borisovich Shimanovsky (1875–1948), artist, collector.

5. Nadezhda Evseevna Dobychina (1884–1949), founder and head of the Arts Bureau (1910–19), which organized exhibitions and commissions for artists. Owner of an art salon on Field of Mars in St. Petersburg that hosted several of the most important exhibitions of the 1910s. After the 1917 Revolution, worked as a researcher at the Russian Museum.

6. Iosif Izraylevich Rybakov (1880–1938?), lawyer, collector. Victim of Stalin's terror; place and date of death are uncertain.

7. Georgy Dionisovich Costakis, (1913–1990) collector, one of the first collectors of the Russian avant-garde. A considerable portion of his collection now belongs to the Tretyakov Gallery. Author of *My Avant-Garde: Collector's Memoirs* (Moscow, 1993). On the Costakis collection, see also *The George Costakis Collection: Russian Avant-Garde Art* (New York, 1981); and *The G. Costakis Collection: Theory-Criticism*, vols. 1–2 (Athens, 1995).

8. The letter seems to be referring to the Chagall monograph being written at that time by Franz Meyer.

9. After Mikhail Gordeyev's death his wife, Zinaida Konstantinovna (d. 1996), moved to St. Petersburg. Presently Chagall's works form the former Mikhail Gordeyev collection and belong to Mikhail Yablochnikov, Zinaida Gordeyeva's nephew.

Endnotes to Letter II

This letter is held in the archive of Mikhail Yablochnikov (St. Petersburg). "Les collines" letterhead. Chagall's response to Mikhail Gordeyev's letter to him (see Letter I). First publication.

1. Chagall seems to mean the Kremlin.

2. Isaak Izraylevich Brodsky (1883–1939), artist. Collected works of his contemporaries that became a portion of the I. I. Brodsky Museum, which is presently a part of the Russian Academy of Arts.

 The information that Chagall's *Vision* first belonged to Brodsky supplements the ownership history of his work, which is described in Gordeyev's letter to Chagall (see Letter I).

3. Chagall clarifies that *The Window* was painted in Vitebsk rather than Lyozno, as Gordeyev used to think (see Letter I).

Endnotes to Letter III

This letter is held in the archive of Mikhail Yablochnikov (St. Petersburg). "Les collines" letterhead. First publication.

1. Costakis. See note 7 to Letter I

EXHIBITION CHECKLIST

YEHUDA PEN

Self-Portrait with Palette, 1898
Oil on canvas
23¾ x 19⅛ in. (60.5 x 49 cm)
Collection Vitebsk Regional Museum,
Vitebsk
Plate 4

Lady with Veil, 1907
Oil on canvas
28 x 14 in. (71 x 36 cm)
Collection Vitebsk Regional Museum,
Vitebsk
Plate 6

Barn on the Vitba, c. 1910
Oil and canvas mounted on veneer
12⅜ x 18⅛ in. (31.5 x 46 cm)
Collection Vitebsk Regional Museum,
Vitebsk
Plate 10

Circus Lerri, 1900–1910
Oil on veneer
17 x 24½ in. (43.5 x 62.5 cm)
Collection Vitebsk Regional Museum,
Vitebsk
Plate 12

Reading a Newspaper, c. 1910
Oil on canvas
17 x 27¾ in. (43.5 x 70.5 cm)
Collection Vitebsk Regional Museum,
Vitebsk
Plate 8

Bathing a Horse, c. 1910
Oil on canvas mounted on veneer
8 x 11 in. (19 x 27.5 cm)
The State Art Museum of the Republic of
Belarus, Minsk
Plate 13

Letter from America, 1913
Oil on canvas
17¹¹⁄₁₆ x 14³⁄₁₆ in. (45 x 36 cm)
Collection Vitebsk Regional Museum,
Vitebsk
Plate 9

Portrait of Marc Chagall, c. 1910
Oil on canvas mounted on cardboard
22¾ x 16⅜ in. (57.5 x 42 cm)
The State Art Museum of the Republic of
Belarus, Minsk
Plate 1

Water Tower Near the Prison (Water Pump on Surozkaya Road), c. 1910
Oil on canvas
12⅞ x 18½ in. (32.5 x 47 cm)
Collection Vitebsk Regional Museum,
Vitebsk
Plate 11

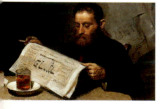

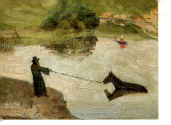

Portrait of a Young Man, 1917
Oil on paper mounted on cardboard
27 x 21⅞ in. (68.5 x 55.5 cm)
The State Art Museum of the Republic of
Belarus, Minsk
Plate 7

House Where I Was Born, 1886–90
Oil on cardboard
12¾ x 18¾ in. (32.5 x 47.5 cm)
Collection Vitebsk Regional Museum,
Vitebsk
Plate 3

The Clockmaker, 1924
Oil on canvas mounted on veneer
27⅞ x 29½ in. (70 x 75 cm)
Collection Vitebsk Regional Museum,
Vitebsk
Plate 5

Self-Portrait, Breakfast, 1929
Oil on canvas
28 x 33 in. (71 x 84 cm)
The State Art Museum of the Republic of
Belarus, Minsk
Plate 14

MARC CHAGALL

The Window, 1908
Oil on canvas
26⅜ x 22⅞ in. (67 x 58 cm)
Collection Zinaida Gordeyeva,
St. Petersburg
Plate 15

Butcher (Grandfather), 1910
Gouache and ink on paper
13⅝ x 9⅝ in. (34.5 x 24.5 cm)
The State Tretyakov Gallery, Moscow
Plate 17

The Jewish Wedding, c. 1910
Gouache and india ink with pen and
brush on paper mounted on cardboard
8 x 11⅞ in. (20.5 x 30 cm)
Collection Zinaida Gordeyeva,
St. Petersburg
Plate 22

Lovers in Black, c. 1910
India ink with pen and brush on paper
9 x 7 in. (23 x 18 cm)
Museum of Art, Pskov
Plate 19

Study for "Rain," 1911
Gouache on paper mounted on
cardboard
9⅜ x 12¼ in. (23.7 x 31 cm)
The State Tretyakov Gallery, Moscow
Plate 20

The Musicians, 1911
Gouache on paper
7¼ x 7⅜ in. (18.5 x 18.7 cm)
The State Tretyakov Gallery, Moscow
Plate 21

The Barbershop (Uncle Sussy), 1914
Oil and gouache on paper
19½ x 14¾ in. (49.3 x 37.2 cm)
The State Tretyakov Gallery, Moscow
Plate 27

The Clock, 1914
Gouache, oil, and colored pencil on paper
19⅜ x 14⅝ in. (49 x 37 cm)
The State Tretyakov Gallery, Moscow
Plate 28

Lovers in Blue, 1914
Oil on paper mounted on cardboard
19⅜ x 17⅜ in. (49 x 44 cm)
Collection Victoria S. Sandler,
St. Petersburg
Plate 42

Lovers in Green, 1914–15
Gouache and oil on paper mounted on
cardboard
19 x 18 in. (48 x 45.5 cm)
Private Collection, Moscow
Plate 66

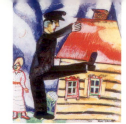

Man on a Stretcher, 1914
India ink and gouache on paper
mounted on cardboard
7½ x 12⅞ in. (19 x 32.5 cm)
State Art Museum, Saratov
Plate 32

My Father, 1914
Watercolor on paper mounted on
cardboard
19½ x 14½ in. (49.4 x 36.8 cm)
The State Russian Museum, St.
Petersburg
Plate 16

Old Man with Cane, 1914
India ink with pen, white, and sepia with
brush on paper
8¾ x 6⅞ in. (22.3 x 17.5 cm)
The State Tretyakov Gallery, Moscow
Plate 36

The Reunion, 1914
India ink with pen on paper
7⅜ x 11⅝ in. (18.5 x 29.5 cm)
Private Collection, St. Petersburg
Plate 33

Self-Portrait at the Easel, 1914
Oil on canvas
28⅜ x 18½ in. (72 x 47 cm)
Collection Valentina Kosintseva,
St. Petersburg
Plate 2

The Shop in Vitebsk, 1914
Watercolor on paper mounted on
cardboard
19⅜ x 19⅛ in. (49 x 48.5 cm)
The State Russian Museum,
St. Petersburg
Plate 18

Strollers, 1914
India ink with pen and white with brush
on paper
8¾ x 7 in. (22.3 x 17.8 cm)
The State Tretyakov Gallery, Moscow
Plate 35

*Study for "Over Vitebsk" (Environs of
Vitebsk)*, 1914
Watercolor and colored pencil on
squared paper
9⅛ x 13¼ in. (23.2 x 33.6 cm)
The State Tretyakov Gallery, Moscow
Plate 37

Study for "Over Vitebsk," 1914
Oil on canvas
7¾ x 9⅞ in. (19.5 x 25 cm)
Collection N. Simina, St. Petersburg
Plate 38

Uncle's Shop in Lyozno, 1914
Oil, gouache, and colored pencil
on paper
14⅝ x 19⅜ in. (37.1 x 49 cm)
The State Tretyakov Gallery, Moscow
Plate 26

War, 1914
India ink and opaque white with pen and
brush on paper
8¾ x 7 in. (22 x 18 cm)
Krasnodar Art Museum, Krasnodar
Plate 34

The Wounded Soldier, 1914
Colored pencil and ink with pen and
brush on paper
9 x 5¼ in. (oval) (22.8 x 13.3 cm)
The State Tretyakov Gallery, Moscow
Plate 31

David with a Mandolin, 1914–15
Gouache on cardboard
19½ x 14⅝ in. (49.5 x 37 cm)
Regional Picture Gallery, Vladivostok
Plate 23

Mariaska (Portrait of Sister), 1914–15
Oil on cardboard
20 x 14¼ in. (51 x 36 cm)
Collection Victoria S. Sandler,
St. Petersburg
Plate 24

Soldiers with Bread, 1914–15
Gouache and watercolor on paper
19⅞ x 14⅝ in. (50.5 x 37.5 cm)
Collection Zinaida Gordeyeva,
St. Petersburg
Plate 30

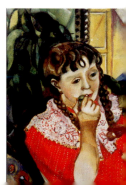

View from the Window, Vitebsk, 1914–15
Oil, gouache, and colored pencil on paper
19⅜ x 14⅜ in. (49 x 36.5 cm)
The State Tretyakov Gallery, Moscow
Plate 25

Wailing Woman, 1914–15
India ink with pen and colored pencil on paper heightened with white
6⅜ x 12⅝ in. (16.2 x 32.2 cm)
The State Russian Museum,
St. Petersburg

Over the Town, 1914–18
Oil on canvas
55½ x 78 in. (141 x 198 cm)
The State Tretyakov Gallery, Moscow
Plate 45

Jew in Bright Red, 1915
Oil on cardboard
39⅜ x 31¾ in. (100 x 80.5 cm)
The State Russian Museum,
St. Petersburg
Plate 39

The Mirror, 1915
Oil on cardboard
39⅜ x 31⅞ in. (100 x 81 cm)
The State Russian Museum,
St. Petersburg
Plate 29

View from the Window, on the Olcha, 1915
Gouache and oil on cardboard
39½ x 31⅝ in. (100.2 x 80.3 cm)
The State Tretyakov Gallery, Moscow
Plate 40

**Illustrations from *Mayselekh* (Tales)
By Der Nister (Pinchas Kaganovich)**

"The Little Kid"

Goat and Rooster, 1916 (cover)
India ink with pen and brush and opaque white on paper
6¼ x 3¾ in. (15.8 x 9.3 cm)
The State Russian Museum,
St. Petersburg
Plate 49

Child in Perambulator and Goat, 1916
India ink with pen and brush and opaque white on paper
5 x 6 in. (12.7 x 15.3 cm)
The State Russian Museum,
St. Petersburg
Plate 51

Goat and Perambulator, 1916
India ink with pen and brush and opaque white on paper
3⅛ x 2¾ in. (8 x 6.8 cm)
The State Russian Museum,
St. Petersburg
Plate 50

Goat in the Woods, 1916
India ink with pen and brush and opaque white on paper
6⅛ x 5⅞ in. (15.5 x 14.8 cm)
The State Russian Museum,
St. Petersburg
Plate 52

"Story of a Rooster"

Grandma Is Dead, 1916
India ink with pen and brush and opaque white on paper
5⅝ x 5⅞ in. (14.2 x 14.9 cm)
The State Russian Museum,
St. Petersburg
Plate 53

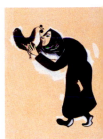

The Little House, 1916
India ink with pen on paper
5 x 4 in. (12.6 x 10 cm)
The State Russian Museum,
St. Petersburg
Plate 54

Night, 1916
India ink with pen on paper
3⅞ x 5 in. (9.8 x 12.6 cm)
The State Russian Museum,
St. Petersburg
Plate 55

Rooster on Steps, 1916
India ink with pen on paper
5½ x 3¾ in. (13.9 x 9.4 cm)
The State Russian Museum,
St. Petersburg
Plate 56

Woman and Rooster, 1916
India ink with pen and brush and opaque white on paper
3⅞ x 3⅝ in. (9.8 x 9.2 cm)
The State Russian Museum,
St. Petersburg
Plate 57

In Step, 1916
Gouache and colored pencil on colored paper
8 x 7 in. (20.3 x 17.9 cm)
The State Tretyakov Gallery, Moscow
Plate 44

The Infant's Bath, 1916
Oil on paper on cardboard
20⅞ x 17⅜ in. (53 x 44 cm)
Museum of Art, Pskov
Plate 43

Lilies of the Valley, 1916
Oil on cardboard
16 x 12⅝ in. (40.9 x 32.1 cm)
The State Tretyakov Gallery, Moscow
Plate 41

The Apparition, 1917–18
Oil on canvas
62 x 55 in. (157 x 140 cm)
Collection Zinaida Gordeyeva,
St. Petersburg
Plate 48

The Promenade, 1917–18
Oil on cardboard
67 x 72¼ in. (170 x 183.5 cm)
The State Russian Museum,
St. Petersburg
Plate 46

Peace to Huts – War on Palaces, 1918
Watercolor, india ink, and colored pencil on paper
13¼ x 9⅛ in. (33.7 x 23.2)
The State Tretyakov Gallery, Moscow
Plate 58

Self-Portrait with Reversed Head, 1918
Colored pencil and india ink with pen on paper
11½ x 8¾ in. (29.1 x 22.2 cm)
The State Tretyakov Gallery, Moscow

The Wedding, 1918
Oil on canvas
39⅜ x 46⅞ in. (100 x 119 cm)
The State Tretyakov Gallery, Moscow
Plate 47

**Murals for the State Jewish
Chamber Theater**

Study for "Introduction to the Jewish Theater," 1920
Paper, gouache, watercolor, white, and plumbago
15¾ x 5⁵⁄₁₆ in. (40 x 14.2 cm)
The State Russian Museum, St. Petersburg

Introduction to the Jewish Theater, 1920
Tempera, gouache, and opaque white on canvas
111⅞ x 309⅞ in. (284 x 787 cm)
The State Tretyakov Gallery, Moscow
Plate 59

Dance, 1920
Tempera, gouache, and opaque white on canvas
84¼ x 42½ in. (214 x 108.5 cm)
The State Tretyakov Gallery, Moscow
Plate 61

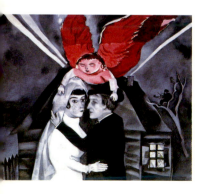

Literature, 1920
Tempera, gouache, and opaque white on canvas
85 x 32 in. (216 x 81.3 cm)
The State Tretyakov Gallery, Moscow
Plate 63

Music, 1920
Tempera, gouache, and opaque white on canvas
83⅞ x 41 in. (213 x 104 cm)
The State Tretyakov Gallery, Moscow
Plate 60

Theater, 1920
Tempera, gouache, and opaque white on canvas
83⅜ x 42¼ in. (212.6 x 107.2 cm)
The State Tretyakov Gallery, Moscow
Plate 62

Wedding Feast, 1920
Tempera, gouache, and opaque white on canvas
25¼ x 314½ in. (64 x 799 cm)
The State Tretyakov Gallery, Moscow
Plate 64

Love on the Stage, 1920
Tempera, gouache, and opaque white on canvas
111½ x 97⅜ in. (283 x 248 cm)
The State Tretyakov Gallery, Moscow
Plate 65

SELECTED BIBLIOGRAPHY

Alexander, Sidney. *Marc Chagall: An Intimate Biography.* New York: Paragon House, 1989.

Amishai-Maisels, Ziva. "Chagall and the Jewish Revival: Center or Periphery?" in Ruth Apter-Gabriel, ed., *Tradition and Revolution: The Jewish Renaissance in Russian Avant Garde Art, 1912–1928.* Jerusalem: The Israel Museum, 1987.

—— . "Chagall's Jewish In-Jokes," *Journal of Jewish Art,* vol. 5 (1978), pp. 76–93.

—— . "Chagall's Murals for the Jewish State Chamber Theatre," in Christoph Vitali, ed., *Marc Chagall: The Russian Years, 1906–1922.* Frankfurt: Schirn Kunsthalle, 1991.

Apter-Gabriel, Ruth, ed. *Chagall: Dreams and Drama, Early Russian Works and Murals for the Jewish Theatre.* Exhibition catalogue. Jerusalem: The Israel Museum, 1993.

—— . *Tradition and Revolution: The Jewish Renaissance in Russian Avant-Garde Art, 1912–1928.* Exhibition catalogue. Jerusalem: The Israel Museum, 1987.

Baal-Teshuva, Jacob, ed. *Chagall: A Retrospective.* Southport, Conn.: Hugh Lauter Levin Associates, 1995.

—— . *Marc Chagall: 1887–1985.* Cologne and London: Taschen, 1998.

Bohm-Duchen, Monica. "The Quest for a Jewish Art in Revolutionary Russia," in Susan Compton, ed. *Chagall: Love and the Stage, 1914–1922.* London: Royal Academy of Arts, 1998.

—— . *Chagall (Art and Ideas).* London: Phaidon Press, 1998.

Bowlt, John E. "From the Pale of Settlement to the Reconstruction of the World," in Ruth Apter-Gabriel, ed., *Tradition and Revolution: The Jewish Renaissance in Russian Avant-Garde Art, 1912–1928.* Jerusalem: The Israel Museum, 1987.

Chagall, Marc. *My Life*. Translated by Elisabeth Abbott. New York: Da Capo Press, 1994.

Compton, Susan. "Chagall's Auditorium: 'An Identity Crisis of Tragic Dimensions,'" in *Marc Chagall and the Jewish Theater*. New York: The Solomon R. Guggenheim Museum, 1992.

—— . *Chagall*. Exhibition catalogue. London: Royal Academy of Arts, 1985.

—— , ed. *Chagall: Love and the Stage, 1914–1922*. Exhibition catalogue. London: Royal Academy of Arts, 1998.

Diener, Marcus, ed. *Chagall: The Marcus Diener Collection*. The Hague: SDU Publishers, 1989.

Friedman, Mira. "Icon Painting and Russian Popular Art as Sources of Some Works by Chagall," *Journal of Jewish Art*, vol. 5 (1978), pp. 94–107.

—— . "The Paintings of Chagall: Sources and Development," in *Marc Chagall: The Marcus Diener Collection*. The Hague: SDU Publishers, 1989.

Frost, Matthew. "Marc Chagall and the Jewish State Chamber Theater," *Russian History*, vol. 8 (1981), parts 1–2, pp. 90–107.

Goodman, Susan T., ed. *Russian Jewish Artists in a Century of Change, 1890–1990*. Exhibition catalogue. New York: The Jewish Museum, 1996.

Haftmann, Werner. *Chagall*. Translated by Heinrich Bauman and Alexis Brown. New York: Harry N. Abrams, 1984.

Harshav, Benjamin. "Chagall: Postmodernism and Fictional Worlds in Painting," in *Marc Chagall and the Jewish Theater*. New York: The Solomon R. Guggenheim Museum, 1992.

—— . "The Role of Language in Modern Art: On Texts and Subtexts in Chagall's Paintings," *Modernism/Modernity*, 1, no. 2 (1994).

Kagan, Andrew. *Marc Chagall*. New York: Abbeville Press, 1987.

Kamensky, Alexander. *Chagall: The Russian Years, 1907–1922*. Translated by C. Phillips. New York: Rizzoli, 1989.

—— . "Chagall's Early Work in The Soviet Union," in Christoph Vitali, ed., *Marc Chagall: The Russian Years, 1906–1922*. Frankfurt: Schirn Kunsthalle, 1991.

Kampf, Avram. "Art and Stage Design: The Jewish Theatres of Moscow in the Early Twenties," in Ruth Apter-Gabriel, ed., *Tradition and Revolution: The Jewish Renaissance in Russian Avant-Garde Art, 1912–1928*. Jerusalem: The Israel Museum, 1987.

—— . "Chagall in the Yiddish Theatre," in Christoph Vitali, ed., *Marc Chagall: The Russian Years, 1906–1922*. Frankfurt: Schirn Kunsthalle, 1991.

—— . *Chagall to Kitaj: Jewish Experience in Twentieth Century Art.* Exhibition catalogue. London: Lund Humphries, with the Barbican Art Gallery, 1990.

Kasovsky, Grigori. *Artists from Vitebsk: Yehuda Pen and His Pupils. Masterpieces of Jewish Art.* Translated by L. Lezhneva. Moscow: Image, 1992.

—— . "Chagall and the Jewish Art Programme," in Christoph Vitali, ed., *Marc Chagall: The Russian Years, 1906–1922.* Frankfurt: Schirn Kunsthalle, 1991.

Kuthy, Sandor, and Meret Meyer. *Marc Chagall, 1907–1917.* Exhibition catalogue. Berne: Museum of Fine Arts, 1995.

Marc Chagall and the Jewish Theater. Exhibition catalogue. New York: The Solomon R. Guggenheim Museum, 1992.

Meyer, Franz. *Marc Chagall: Life and Work.* Translated by Robert Allen. New York: Harry N. Abrams, 1964.

Pagé, Suzanne, ed., *Marc Chagall: Les Années Russes, 1907–1922.* Exhibition catalogue. Paris: Musée d'art moderne de la Ville de Paris, 1995.

Shatskikh, Alexandra. "Marc Chagall and the Theatre," in Christoph Vitali, ed., *Marc Chagall: The Russian Years, 1906–1922.* Frankfurt: Schirn Kunsthalle, 1991.

Vitali, Christoph, ed. *Marc Chagall: The Russian Years, 1906–1922.* Exhibition catalogue. Frankfurt: Schirn Kunsthalle, 1991.

Voznesensky, Andrey. *Chagall Discovered: From Russian and Private Collections.* Moscow: Sovietskiy Khudozhnik Publishers, 1988.

INDEX

References to artworks illustrated in this volume appear first and in italics.